SOUTHWESTERN SOJOURN

SOUTHWESTERN SOJOURN

A Photographer's Journal

TEXT AND PHOTOGRAPHS BY JAMES W. PARKER

PALMER CREEK PUBLISHING

Published by Palmer Creek Publishing, Rochester Hills, Michigan

Photographs & Text by James W. Parker
Designed by James W. Parker

Other Books by James W. Parker

A Disappearing Agrarian Landscape
Stories Told In Things Left Behind

978-1-7349100-1-8

For my friend and fellow adventurer, Jim Beasley, and

for my wife Karyn Kozo, whose love and support always buoys me up

PREPARATIONS, CORRESPONDENCE, EXPLORATION

INTRODUCTION

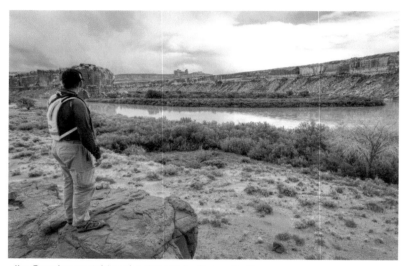

Jim Beasley, watching the river at Anderson Bottom

Before we begin, a few words...

This trip actually begins in 1976, when I worked at William A. Robinson, a marketing and promotion agency in Chicago. My first salaried job. Employed as an assistant art director, I worked alongside talented writers, art directors and account executives, learning as I went under the tutelage of Hugh Lambert. One of those writers was Lynne Carmack, a young ambitious wordsmith, who later went on to craft Bill Robinson's 100 Best Promotions series. Over the years, we both changed jobs and

lost touch with each other, until reconnecting at an art show in Houston one spring.

The Bayou City Art Festival runs twice a year, and as an itinerant artist, I participated as part of my annual pilgrimage to Texas. During one of these shows, Lynne got in touch somehow (I don't even remember how, exactly). She and her husband, Jim Beasley met my wife Karyn Kozo and I for dinner one night. We would touch base on and off over the next few years, and it was during one of those dinners that Jim brought up the idea of canoeing the Green River.

Fascinated by the unique geology of the Colorado Plateau, Jim had been poring over maps of Upheaval Dome and Canyonlands. He had been reading about John Wesley Powell's expeditions down the Green and Colorado Rivers, and had been impressed by a unique geological formation visible from the Green River. The two buttes, when first seen from the river, looked like a fallen cross, and Powell christened them The Buttes of the Cross. Further down the river, it was apparent that the Buttes were two separate formations. Jim was obsessed. He told us about his revelation at that dinner, and suggested that a trip down the Green River would be fascinating. He went on to describe

some of the other landmarks and historic features along the river. There were old grazing lands along the river bottoms; an old cowboy bedspring high on a cliff; ancient Pueblan ruins everywhere, small arches and granaries. And best of all, he described the river itself as peaceful. Flat water. No rapids to contend with. Sounded perfect.

The stretch of water from Green River, Utah down to the confluence with the Colorado River runs about 120 miles. There are three major put-ins. The first is the boat ramp in Green River. The second, at Ruby Ranch, is 23 miles downstream. The third, at Mineral Bottom, has the most picturesque approach. Ruby Ranch to Mineral Bottom is 47 miles, and flows through Labyrinth Canyon; while the trip from Mineral Bottom to the take-out at Spanish Bottom is 52 miles.

Jim's plan was to do the 52 mile stretch from Mineral Bottom to Spanish Bottom, with stops at Anderson Bottom, Turks Head, and Seven-Mile Ranch. Layover

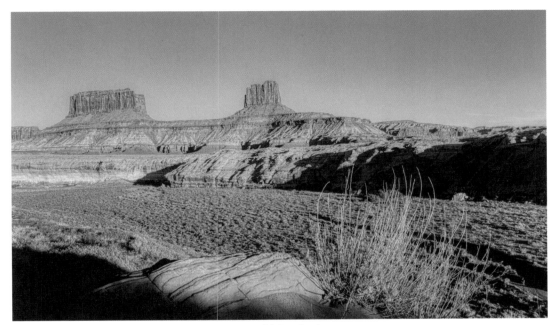

The Buttes of the Cross from a rincon along the old river bed.

days would allow us to hike up out of the river canyon, looking for ruins and spectacular scenery to photograph. He asked me if I'd be interested in such a trip. I was, although not being much of a water person, I had my reservations.

My main experience with river running had been on a weekend canoe trip with the Boy Scouts in high school, and on a raft trip in the seventies with co-workers. That trip started badly, when my girlfriend

at the time caused the raft to go over a 6' waterfall, and overturn, dumping me under the craft. In her panic to get the raft out of the whirlpool under the cascade, she kept beating me about the head and shoulders with her paddle. Luckily I was able to regain the boat, but that experience left me with a permanent mistrust of rivers in general.

Over the next several months, Jim & I tried, unsuccessfully, to fix dates for

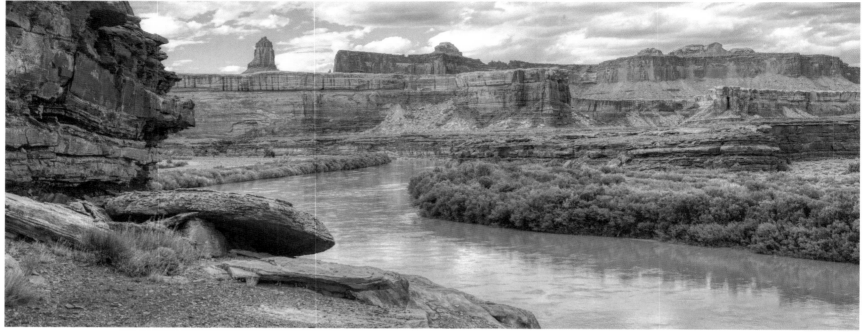

The Green River at Turks Head, our third landing, and one of the prettiest camping spots along this stretch.

the expedition. Fall is generally recognized as the best time to run the Green, as the water is lower, and sandbars dry out and become visible. The river is overgrown in many places with tamarack trees, or "salt cedar", as Jim called them, which makes access to the shore nearly impossible. Little tributaries join the Green, sometimes subject to flash flooding after late-summer storms. In springtime, the river is high, with snow-melt raising the water level, and increasing the flow. Summertime is naturally the hottest, with temperatures at the canyon bottom approaching the 100 degree mark. In my opinion, September is probably the best time to canoe the river, due to the increased availability of camping spots on the sandbars, and lower flow. But we couldn't

manage to find dates that worked for the both of us.

Several years went by. We discovered a couple of resources that rented canoes in Moab, and provided jet-boat access from the end-point back up the Colorado River. Below Spanish Bottom, the river gets narrow, and runs through Cataract Canyon, where Class IV-V rapids are difficult and dangerous. Most canoe trippers pull out at Spanish Bottom, and arrange for transportation back to Moab. At the time, two outfitters ran jet-boats from Spanish Bottom: Tagalong Expeditions and Tex's Riverways. When we finally got it together to make concrete plans, only Tex's was still running boats. There are many outfitters offering

raft expeditions and single day rentals, but only one outfitter still running the jet boat from Spanish Bottom.

Beasley found a number of first-hand accounts of people who had run the river. We both read up on the trip, and began to build a bucket list of photo ops and landings. Jim went through Google Earth with a fine-tooth comb, looking for camping sites mentioned online, and in books. We pored over Michael Kelsey's book, "River Guide to Canyonlands National Park", doing our best to wade through the tiny type. Finally, in early 2019, Beasley called me, and said, "The trip is on". He had booked the trip for early May, a time when the weather is cooler, but the river is running high with snow-melt.

Our original outfitter, Tagalong, was no longer running trips via jet-boat, but the other company, Tex's Riverways, was able to fit us into the schedule in early May. Beasley had planned an ambitious trip, covering 52 miles in ten days. The lengthened time span meant that there'd be lots of time to lay over and explore the side canyons and benches along the way. Rather than put in at Ruby Ranch, Jim had us starting from Mineral Bottom and floating down to the Confluence of the Green and the Colorado Rivers, and taking the jet-boat back up the Colorado. There was only one hitch. Although Jim had put down a deposit, I had a potential conflict during the early May dates he had reserved. But I wouldn't know until late January if I was accepted to the Brookside Art Annual, and if my art show schedule would give

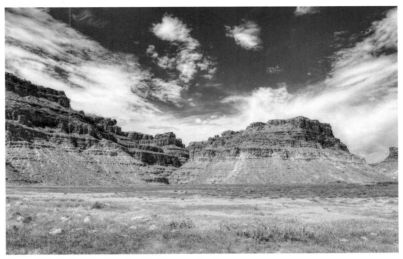

Spanish Bottom, from the Dollhouse Trail.

me time to meet Beasley in Utah. I also had other shows tentatively scheduled in May, one of my first income-producing months of the northern show season.

By April, my show schedule had worked itself out. I cancelled one show in Michigan, and Beasley was able to change the dates so that I could run to Kansas City for the Brookside show, and then meet him in Moab mid-May for the trip. I planned to leave the trailer in Kansas City, and spend a week in the desert southwest making photographs beforehand. I spent most of April gathering gear, planning menus, and dehydrating food. Ten days on the river required packing a lot of ingredients, for I wasn't keen on taking backpacking meals for that long a period. We agreed to bring our own breakfast and lunch, and that I would cook the evening meals. More on the cuisine later...

After the show in Kansas City, I drove the art trailer up to a large storage facility near Smithville. For $35, I was able to leave the trailer for a month without hauling it to Utah and back. Talking with the owner, Doug Lowe, for a few minutes, gave me confidence that the trailer would be fine for the three weeks it would be parked here. Doug gave me a key to the lot's gate, some promotional gifts, and a wooden nickel inscribed with the phone number and name of the establishment. I carried that nickel for the entire trip. After visiting with Doug, and parking the trailer, I set out for Colorado and parts west. It was a bright, sunny day, perfect for driving.

Beasley and Lynne called when I was west of KC, and told me I should stop in Lawrence to look around. The sky was threatening, and since it was already mid-afternoon, I ignored that advice. Past the Tallgrass Prairie, I felt the tugging of a picture, but resisted. The sky darkened, and after Topeka, the rain followed me all the way across Kansas. Finally stopped for the night at Colby, I found an open diner, and ate a forgettable meal. The Quality Inn there was undergoing some sort of odd restoration, and felt like a ghost town. Too big for the town, it featured long hallways and a deserted bar. Next morning, I was happy to discover a Starbucks at the Petro Truck Stop. I was fueled and ready to go, but the rain had only intensified.

Along I-70, long stretches of construction were punctuated by endless fields filled with standing water alongside the road. Mid-

May, and still no opportunity for the farmers to plant. Eastern Colorado has never been particularly hospitable to farmers. Timothy Egan's "The Worst Hard Time" chronicles the story of those farmers who tried to eke out an existence on these arid lands. I passed Vona, Colorado. During my last trip East on I-70, I had stopped here and photographed the elevator and the main street. Too rainy to stop today.

Then Arriba, where the old wooden elevator has been torn down

The elevator at Vona, Colorado

since I was last there. Flagler. Genoa. And Limon. I gassed up in Limon, and then drove through town to find the elevator that got me started on the "Disappearing Agrarian Landscape" series. The elevator now appeared to be much more prosperous than in

the fall of 2004, with trucks waiting to off-load grain. Grain augers waiting for new owners blocked my shot in the parking lot.

In Limon, I faced a decision. Stay on I-70 through Denver, and up into the front range, or south to Colorado Springs, and over Wolf Creek Pass to Durango? The rain had not let up, and the forecast was for snow in the high mountains. I opted for the southern route.

US 24 cuts southwest through several small ranch towns before joining up with I-29 in Colorado Springs. I hadn't been down this road since my trip to Yellowstone and the Tetons in 2003. The towns looked prosperous, if not well-fed, and the fields were in somewhat better shape than the flat prairie to the east. Nothing photographic caught my eye, and soon I was one of thousands of cars headed for Pueblo and southern Colorado on I-29.

At Walsenberg, the rain finally let up. My constant companion for the past two days, the rain had depressed my spirit, and dampened my photographic ambition. The forecast for the next few days called for more moisture across the entire southwest. Needed moisture, to be sure, but unseasonably wet. Usually by May, the temperatures are in the low 80's and the ground has already dried out.

I headed up into the mountains on US 160. The road into the San Juans is a pretty road, and between Walsenburg and Pagosa Springs, you are greeted by alternate high desert and snowy

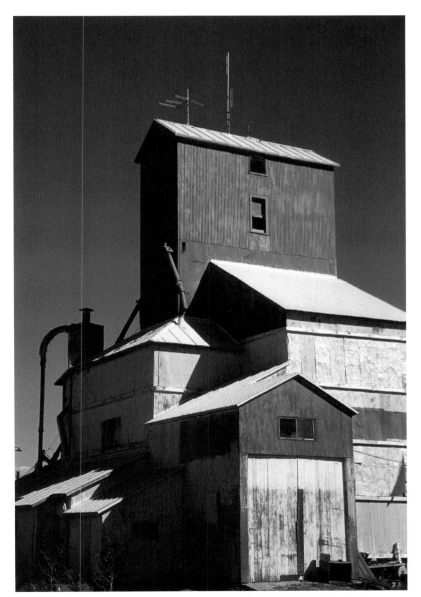

The old wooden mill in Arriba, CO, now demolished.

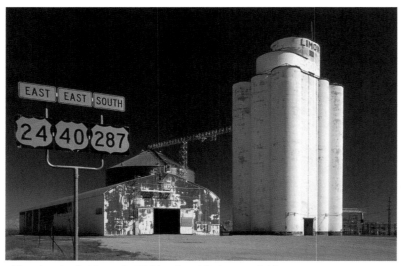

The elevator in Limon in 2004 when I first passed this spot.

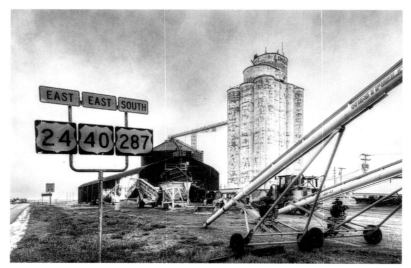

The grain elevator in Limon, photographed in a pouring rain storm. This is where I left the interstate and began my journey

mountain peaks, not to mention Great Sand Dunes National Park. By this time, I had decided to revisit Mesa Verde and see parts of Utah and southwestern Colorado that I hadn't had time to explore on previous trips. With almost a week to kill before meeting Beasley in Moab, the possibilities were endless. Go south to Trinidad, Santa Fe, and loop around through Chaco Canyon, which had been on my bucket list for a good while? Betatakin and Keet Seel in Navajo National Monument were not yet open to visitors in early May, so that was out. Monument Valley held no special appeal; been there, done that. So I set my sights on Durango and Cortez.

Durango had grown immensely since I was last there, almost forty years prior. Sprawled along the Animas River valley, strip malls and big hotels had sprung up along the highway. Remembering none of that, I drove slowly up Main Street, looking for appropriate lodging. The Durango in my mind was a quaint Western town, with wide streets, and small boutique motels lining its sidewalks. This Durango had very little of that charm, although I did find a charming Mexican restaurant teeming with tourists to satisfy my beans and cheese craving.

WEDNESDAY, MAY 8

MESA VERDE

Next morning, the sun was still shining as I drove West on US 160 towards Mesa Verde. It's a short ride, up through Hesperus, a marvelous little ranching community. I arrived at the Visitor Center in time to snag a ticket for the 10 o'clock tour of Cliff Palace. The last time I'd been to Mesa Verde was on my way back from Phoenix in 1980. I'd arrived late in the day, and had only been able to catch a glimpse of Cliff Palace from the over-look before the setting sun and park closing hours forced me to head to Cortez. Now I'd have the opportunity to visit this magnifi-cent structure up close and personal, with 50 other tourists.

With an hour or so before the tour was to begin, I drove through the Morefield Campground. Lots of open campsites here, but cold and exposed. Morefield does have a store, toilets and a gas station (pricey). It didn't look as if getting a site would be an is-sue, so I postponed the decision, dependent on the weather.

After a 30 minute drive to the Cliff House trailhead, I gathered some gear and put on my foul weather gear. The tour group gathered in the rain (yes, it was raining again) under a sun shade near the viewing deck. I tried to sneak my Canon 5DsR under my rain jacket, but it wasn't a particularly good fit. I snapped a couple of images off the viewpoint and then walked back to the truck to swap the camera out for the smaller Sony NEX-7. Ranger

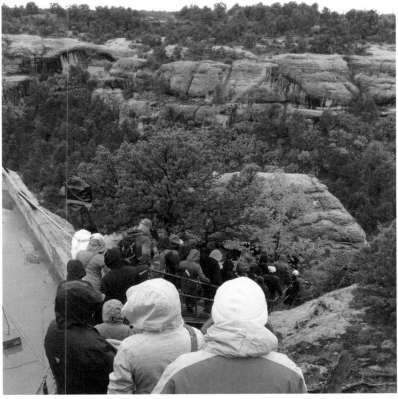

Descending the stairs to Cliff Palace with 50 of my closest friends.

Rick (not his real name) arrived, and cheerily gave us a few rules for the trip down into the canyon: "Keep up. Watch your step. Don't take anything. Don't leave fingerprints."

I hung at the back of the line, with an older ranger and another fellow who had been in the canyon many times. It was also easier to make photographs that didn't have other humans in them from the back of the line.

Up close, Cliff Palace is awe-inspiring. The dwellings, granaries and kivas fit together in a well-planned helter-skelter, under the overhangs and nooks of the canyon wall. The Anasazi, or Ancient Puebloans, as we now refer to them, were master masons, and this example of their later work shows incredible attention to detail. Every stone, every block fits together perfectly. I was told that the overhang reaches back almost 200 feet. Cliff Palace is one of the largest cliff dwellings in America, and may have housed up to 150 people. As we toured the structure, the two rangers were careful to keep us on a path below the main structure. We were able to see many of the kivas, and at one point,

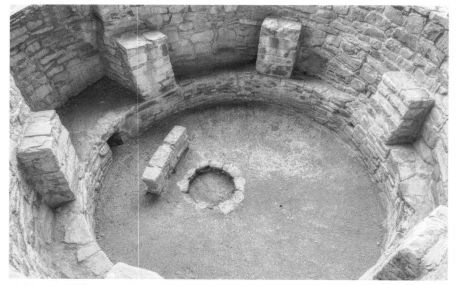

A kiva at Cliff Palace, showing the sipapu, fire pit and supports for the roof.

they let us glimpse into the 4 story Square Tower, reconstructed by the Park Service in the 1930's.

Ascending to the mesa top by way of a second stairway, the rain began falling again. It had magically stopped during much of the Cliff Palace Tour, but as I reached the parking lot, it began again in earnest. I bid my ranger friend goodbye, and continued around Cliff Palace Loop and Mesa Top Loop.

There is a lot to take in, at Mesa Verde. May is early season there, and the unseasonably cold weather meant that the road out Wetherill Mesa to Long House was closed; the Balcony House was closed; and Spruce Tree House was closed due to rock fall. Still, the loops on top of Chapin Mesa offered a lot of vistas, even on a cloudy, drizzly day. From Cliff House, the road loops south around the mesa, and offers several viewpoints. Past the Balcony House trailhead, the Soda Canyon Overlook trail leads you to a ledge overlooking the canyon. Clouds and mist shrouded the gentle path. At the end, views of Balcony House across the way were the reward, although even with a telephoto lens, the ruin was barely visible. It looked as if some rangers were working inside the alcove, although at a distance it was hard to tell what was going on.

Another loop branches off from the Chapin Museum, and visits spectacular views of Navajo Canyon, Square Tower and, from Sun Point, a glorious look at the many communities in Cliff Canyon. From Sun Point, you can see Oak Tree House, Cliff House, Sunset House, and several other smallish ruins. I brought

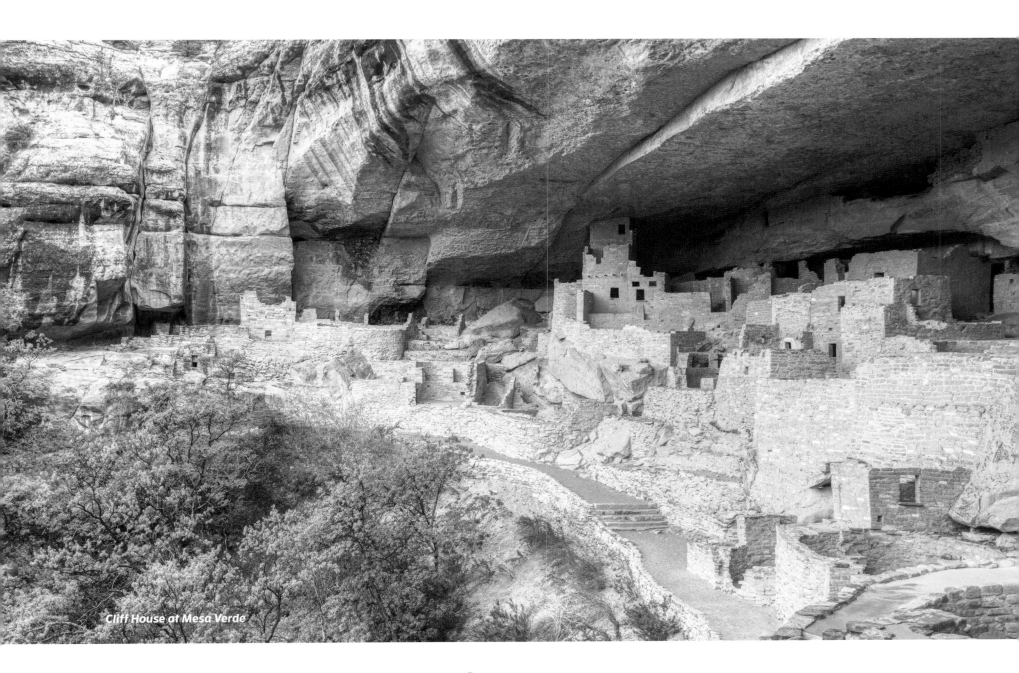

Cliff House at Mesa Verde

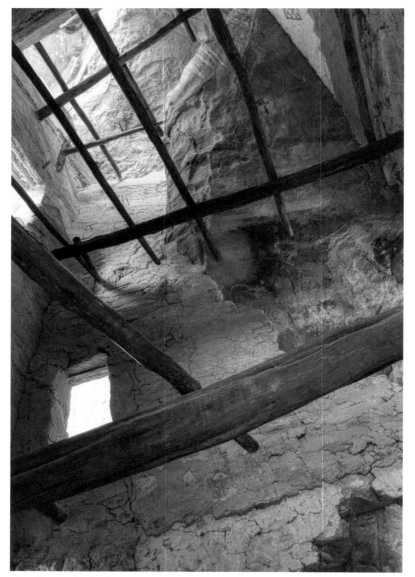

Looking up in the Square Tower at Cliff Palace, floor supports and artwork can be seen if you look closely.

out the longest lens I own here, and put together a stitch panorama of the canyon. For a while, it looked as if the rain might cease completely. The light was soft due to the overcast sky, and I spent quite a few moments just taking in the scene. Just down the road, a spur leads to the Sun Temple, and more good views of the Cliff Palace. At this point, my stomach began to growl.

Midway between the entrance road and the campground, the Far View Lodge commands a beautiful spot atop Chapin Mesa. There are hotel rooms to be had here, perhaps worth it for an early-morning or late-evening photo shoot bivouac; a souvenir shop; and a dining room. I found something to eat, and watched the sun pop out of the clouds. Feeling invigorated, I headed back to the Chapin Mesa Archeological Museum after lunch to see Spruce Tree House.

For a couple of hours, the sun blessed us with its warmth. There were many people here, taking photographs, walking through the museum, and hiking down the path towards Spruce Tree House. I joined them, but cut off to the left, where the remains of an Ancient Puebloan dam was visible at the edge of the drop off. Spruce Tree is one the best preserved sites in the park, and up until 2015, was accessible to the public for unaccompanied visits. Unexpected deterioration of the alcove has led to intermittent rockfall, however, and the ruin is now off-limits to the average human. Along the path towards the petroglyphs, the serviceberry was in full bloom.

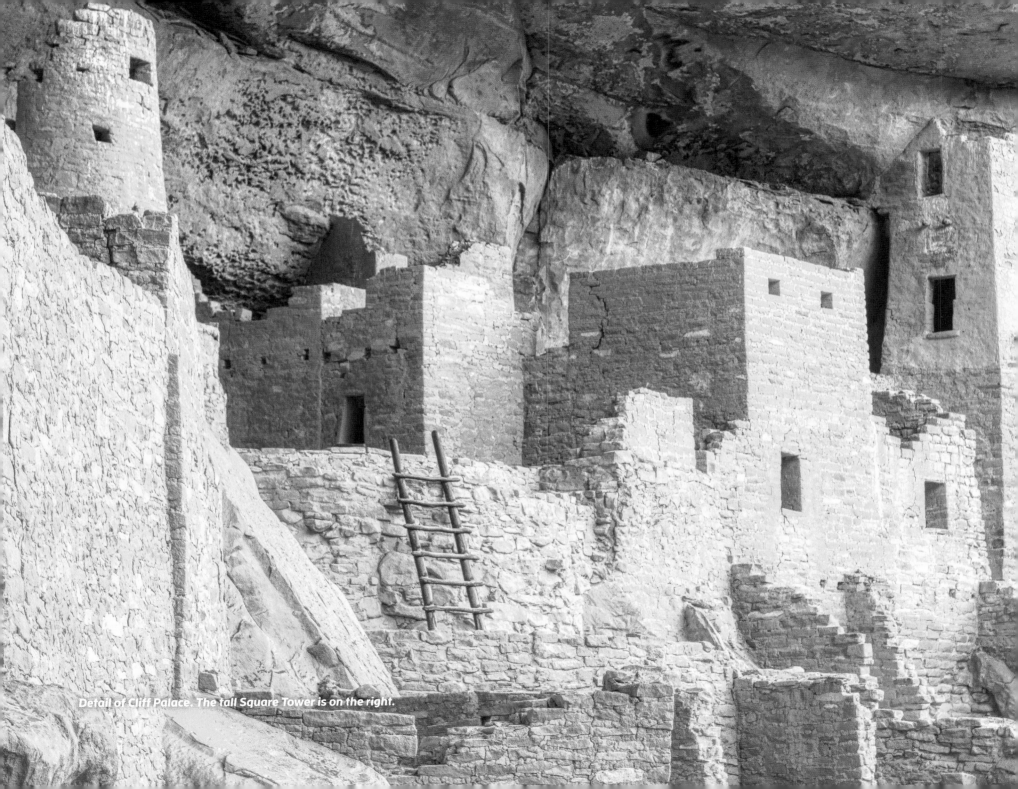

Detail of Cliff Palace. The tall Square Tower is on the right.

The view from Sun Point, showing the many settlements under the cliff rim. From left to right, Oak Tree House, Cliff Palace (in the center), Sunset House

After Spruce Tree, I paid a visit to the museum, where dioramas and prehistoric artifacts added to my understanding of this fascinating culture. It's definitely worth a visit, as is the adjacent bookstore. The architecture of the park buildings is worth a mention as well, echoing the earlier masons with its sandstone brick and mortar.

Back on the road, hoping to capture some grand vistas, I made another trip around the Mesa Loop, stopping again at Navajo Canyon, briefly. Up the road, the trailhead parking for Square Tower was open, so I stopped, and hiked down the short trail to see this impressive structure. The tallest in the park, Square Tower is nestled in the crook of the canyon, with a few kivas and dwellings. The sun had once again disappeared, both good for the soft light, and bad for the foreshadowing of more moisture from the sky.

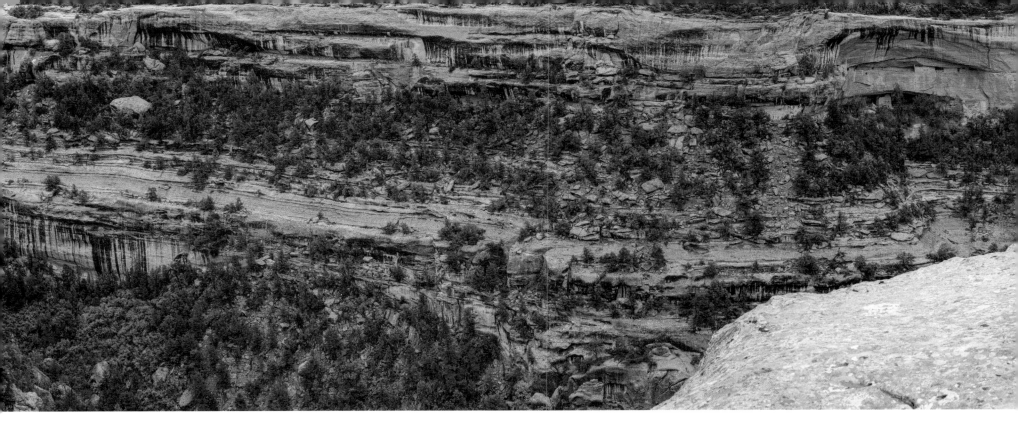

The clouds continued to lower. On the mesa top near Far View, it became apparent that the weather was going to continue misbehaving. I made the decision to head to Cortez as I passed the Morefield Campground. Driving into the store parking lot to use the facility only reinforced my decision. The location is largely exposed, with no large trees for cover, and the wind was starting to kick up.

In Cortez, I found a cheap motel sufficient for the night, and inquired where one might find a tasty steak. Across the street and down a block sat the Shiloh Steak House, where indeed I found a steak and a salad. Quiet, with good service, well recommended. Not the best steak I have ever had, but it fit the requirements of juicy, flavorful, and meaty. Seems as if Shiloh's has improved since the bad reviews on Trip Advisor from several years back.

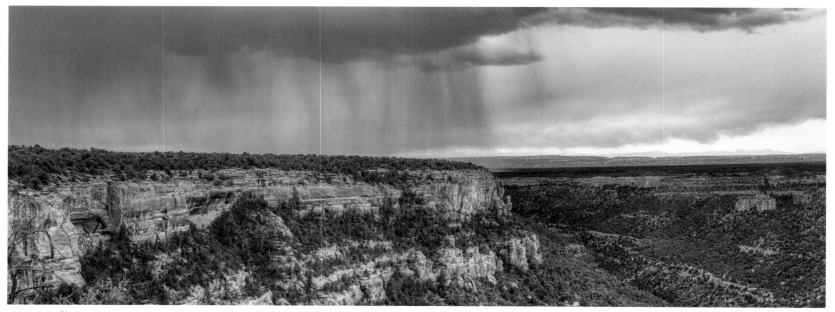

Upper Left: Serviceberry blooms along the trail. Upper right: misty view from the Soda Canyon overlook. Bottom: a passing shower over Navajo Canyon

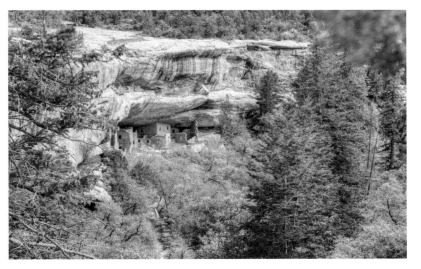

Left: the Park Service office and museum, constructed to mimic the native architecture. Upper right: Spruce Tree House. Lower right: a cottonwood tree grows in the wet area once dammed by the Ancient Puebloans to provide water for Spruce Tree House.

THURSDAY, MAY 9

SHIPROCK

In the morning, I decided to make an early morning run down to Shiprock. Shiprock is one of those iconic Southwest locations that is easy to find, but hard to get to. Located several miles to the west of the infamous Highway 666 (now US 491), several dirt tracks lead along the volcanic dike towards the extinct core. When I was last there, I climbed the dike in late afternoon, and then made pictures from the western side. That visit, I stayed overnight in Farmington, NM, and returned for sunrise images the next morning, but was cursed by a bluebird sky. Today promised better cloud formations to add a bit of drama to the image. Arriving at the scene, there were several Diné vehicles parked near the dike. Not wanting to disturb them, I turned around and found another access road a bit to the east.

Crossing the cattle-guard, I left the truck with tripod in hand. The Navajo name for the peak, Tsé Bit'a'í, **"rock with wings"** or **"winged rock"**, refers to the legend of the great bird that brought the Navajo from the north to their present lands. It is an impressive sight, magnetic in its presence. I walked closer, following the dirt track. For a religious icon, it's funny how much trash is strewn around the field. I saw many broken bottles; shotgun shells; an old stove discarded in a dry wash; and a pair of sneakers cuddling with two empty beer bottles.

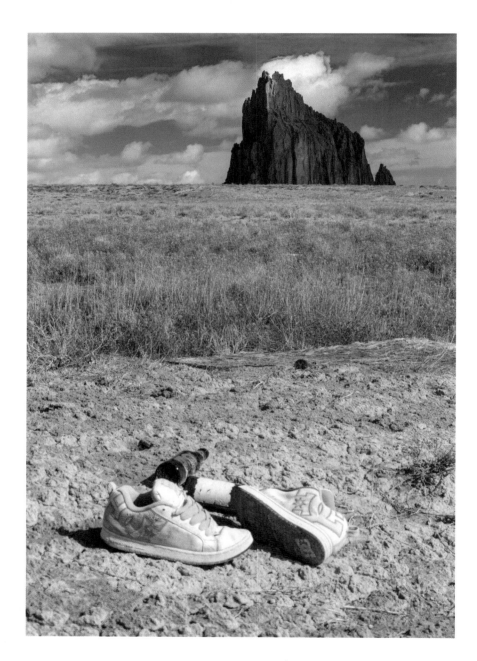

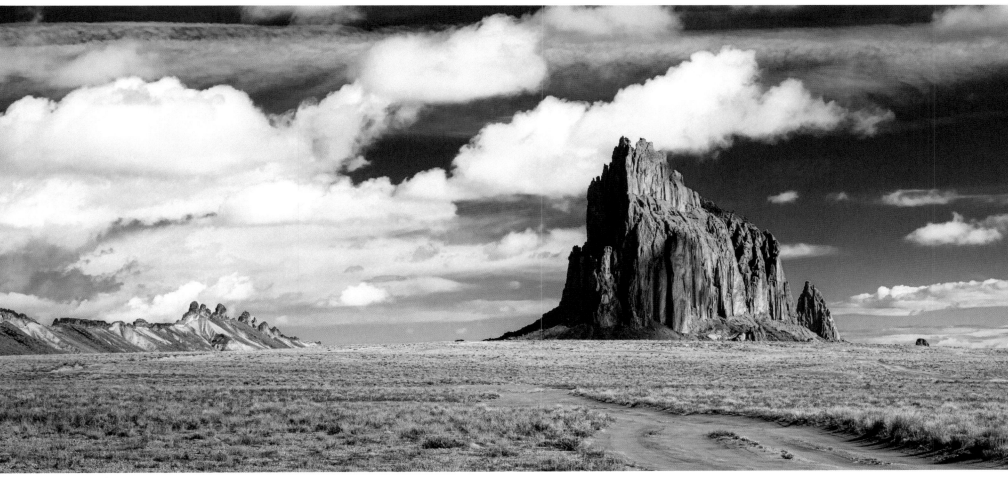

Tsé Bit'a'í, early morning

I was tempted to walk to the base of the mountain, but was torn between a quest and a desire to travel onward. When I got back to the vehicle, a couple of locals drove in and waved, as I headed off to start the rest of the day.

FOUR CORNERS

Heading North on highway 491, I came to a crossroads. Continue on 491 back to Cortez, or head west into Utah? With a few days remaining until I need to be in Moab, I decided that Hovenweep would be my next destination. Highway 160, nicknamed **"The Trail of the Ancients"**, leads westward towards several lesser known Anasazi settlements. Hovenweep was one of the last homes to these early American farmers before they departed the area in the 13th century.

> *"By the end of the 13th century, it appears a prolonged drought, possibly combined with resource depletion, factionalism and warfare, forced the inhabitants of Hovenweep to depart. Though the reason is unclear, ancestral Puebloans throughout the area migrated south to the Rio Grande Valley in New Mexico and the Little Colorado River Basin in Arizona. Today's Pueblo, Zuni and Hopi people are descendants of this culture."*

– From Hovenweep National Monument website

Just a few miles down the road, a short driveway leads to the Navajo Four Corners Monument. It is the only place in the continental US where you can stand in four states at one time: Arizona, Colorado, New Mexico, and Utah. It is a popular tourist spot, as evidenced by the ring of vendor booths surrounding the monument itself. It costs five bucks to get in, and a few folks were taking selfies. Easy enough to find someone to snap a picture of me on the spot where the four states meet.

I wandered around the monument for a bit, looking at the jewelry and ceramic work on display. One woman had some nice bolo ties made by her husband, Lee Nezzie. Many of the designs were of Kokopelli, the legendary god of prosperity, creativity and

Four Corners Monument straddles Utah, New Mexico, Colorado and Arizona

good luck. Some say he is also the god of fertility. I bought one of the ties from her, and watched while she attached gold tips to the braided leather.

Heading east again for a few miles, the Trail of the Ancients joins Highway 160 in the middle of the Colorado desert. Turning north seemed to commit me fully to this journey before the

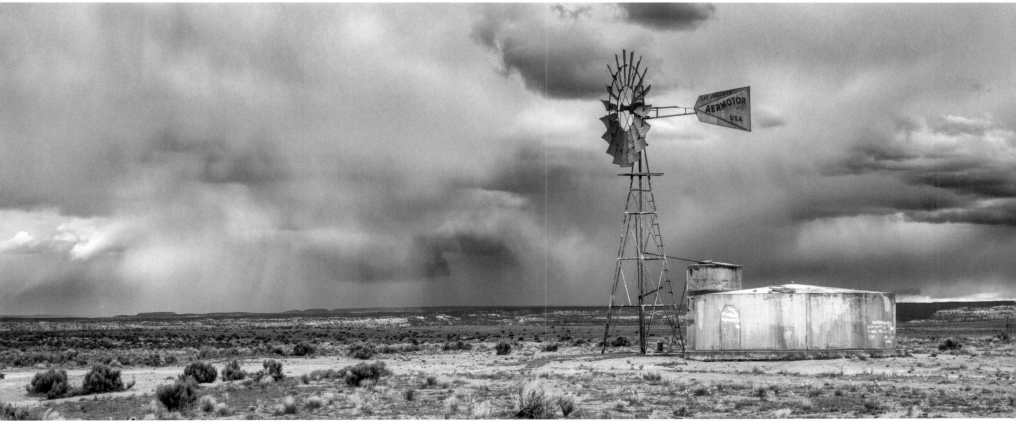

Windmill and holding tank near Hovenweep

journey. The landscape was stark, dry, dotted with agave spikes and sagebrush. Not much ranching out this way. At Aneth, the landscape gave way to some scattered pine. The road turned north on Ismay Trading Post Road, and followed McElmo creek for some distance along hills and gullies. The sky was darkening, and clouds were gathering. Gone was the sunshine of the early morning at Shiprock, replaced by distant storms and needed rain showers.

I followed the county roads towards Hovenweep. As I got closer, a large windmill, silhouetted by the sky, turned furiously in the howling wind. My instinct told me to turn the truck around to make a picture as I drove past. Out in the desert, the soil was red sand and clay, held together by hardy bushes and low plants. The windmill fed a large storage tank, tapped into an unknown aquifer. There were no cattle in sight, no fences, nothing but a dirt road leading to the water source.

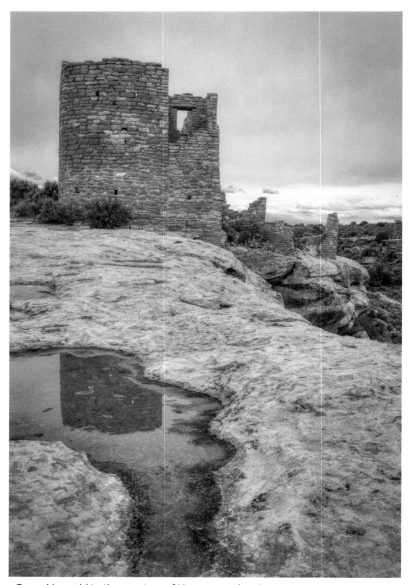

Gray skies add to the mystery of Hovenweep's ruins

HOVENWEEP

At Hovenweep, I stopped at the entrance station, where a small bookstore and souvenir shop handed out informational booklets. Close at hand was a short loop trail around the Square Tower Group. Shouldering pack and tripod, I set out to see what the ancient Puebloans had built here.

The trail winds around a shallow canyon, with many structures dotted throughout. I spent a couple of hours here, walking counter-clockwise, marveling at the masonry skills of these people. No one knows precisely what the buildings were used for. Perhaps the tall square towers were defensive positions. Some most certainly served as dwellings. The entire encampment encompasses about 3/4 of a mile of canyon, with some structures sitting atop irregular boulders, some nestled into protective alcoves. There were granaries, towers, and the impressive remains of Hovenweep Castle.

Coming out the canyon in late afternoon, I decided to camp overnight. A separate paved campground loop leads to semi-secluded RV sites, with a central wash station. Running water and flush toilets! For $8 a night, this is a bargain. There were plenty of spots... I circled twice before backing the truck into

one close to the wash and water. The campground host had his Airstream just a few steps away. Counting my spare change to make up the campground fee, when I went to get the envelope, I realized that I could just as easily have written a check! Chatting with the host, and earlier with the ranger at the welcome center, I thought to myself, "These are some of the nicest park folks I have met in a while".

Full of helpful information, and eager to share his knowledge of the area, the host pointed me toward the Holly Trail, a four-mile trip up-canyon to another set of ruins.

I quickly appreciated the peace & quiet of this remote spot, away from the crowds at the more popular Mesa Verde. The picnic shelters did not offer true protection from the drizzle that came while I was cooking my backpacker's dinner, but I appreciated the solid picnic table. Too tired to start a campfire in the grate, I tumbled into my sleeping bag under my truck cap. Warm, dry, safe. Another nice thing about Hovenweep? The campground had cell service.

After a restful night, a quick breakfast of oatmeal, and a healthy dose of coffee, I packed up the truck, and decided to walk up the Holly Trail. It was worth the effort. Starting off from the campground, it descends into Keely Canyon via a narrow slot. I had to take off my pack in order to slither through sideways. Big rock cairns mark the entrance and exit, but if I had not known about it, I probably would have missed the trail completely.

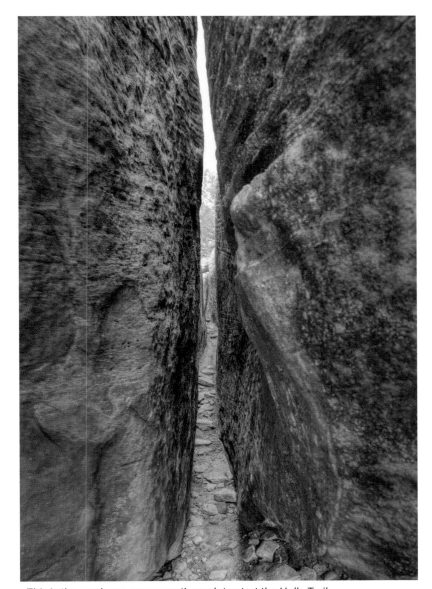

This is the crack one squeezes through to start the Holly Trail

Moody views on the walk north towards Holly and Hackberry, in Keely Canyon

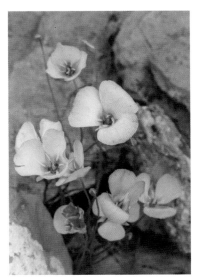

Upper left: Boulders split, as if by an ax. Lower left: Mariposa lilies dot the spring landscape. Lower right: small cairns mark the path. Right: the trail leads through colored strata of limestone and sandstone.

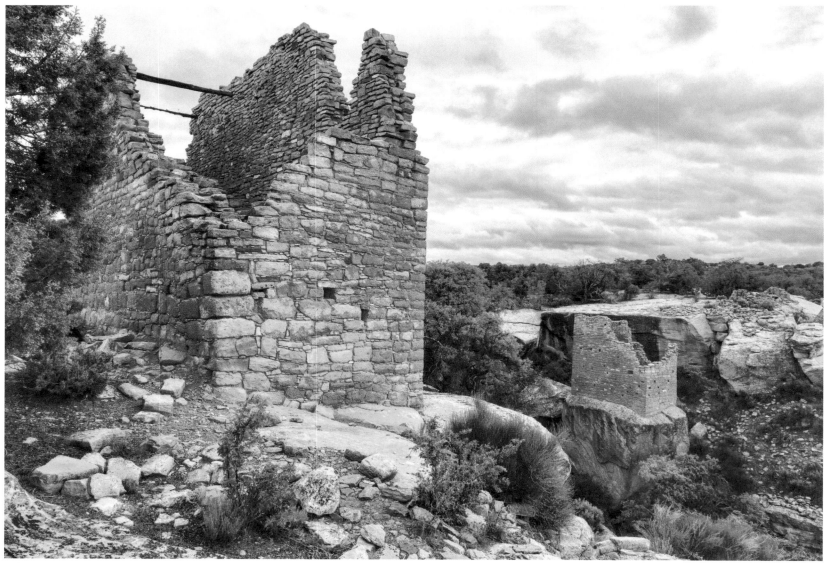

The ruins at the Holly site, Hovenweep. In retrospect, the cloudy day added an air of mystery to the ruins. The walking was not difficult. Many spring blooms dotted the desert floor, including wild rhubarb, mariposa liy, prickly pear cactus, and others I could not name.

Continuing through a mostly dry wash and winding up through the canyon was a beautiful walk. I met exactly one couple the entire journey, on their way back to camp. The path is easy to follow, and after a mile or so of hiking along the stream bed, it cuts left into another canyon, and follows up the bank a bit. Opening up into a broad valley with many wildflower blooms, I was amazed at the diversity of growth along the path. One plant resembled rhubarb, with broad green leaves and showy red flowers. I learned later that it was indeed a relative of the rhubarb, and may have been cultivated by the ancient Puebloans. Dozens of mariposa blooms dotted the hills, along with prickly pear, and plants I could not name.

About two and half miles up the trail, a pile of rubble marks the spot where an Anasazi ruin once stood. Climbing gently out of the canyon, the path leads up to the very edge of the rim, where the impressive Holly ruins stand guard. The ancient Puebloans often settled where there was a consistent water source, either a spring or a seep. The Holly grouping was no different. Crossing over what might have been a dam in earlier times, the trail ends at a small parking lot, accessible by 4WD. Walking is a much better way to experience this area, if one has the time. Slower, more peaceful, walking

A species of wild rhubarb, perhaps cultivated by the Ancients.

allows you to assimilate quietly into the landscape, admiring and appreciating each bloom, each field of flowers, the scent of the small pines. I took many photographs, mostly to document my experience.

Eating a small hand lunch of nuts and dried fruit, I returned along the same path. The sky continued to threaten rain, with low gray clouds, but I managed to regain camp without a soaking. Deciding to stay another night, I put another eight bucks into the self-serve kiosk, and marked my spot of the previous night. Back in the truck, I stopped at the welcome center and spoke with the head ranger again. I asked about the access roads to Cajon and Cutthroat — two of the other units in the park. Cajon seemed more accessible; Cutthroat is closed due to some access issues.

There were other tourists visiting at the center, and it seemed an opportune time to watch the short welcome video. Hovenweep is a peaceful oasis in the desert, and the park service folks working there obviously have a love for this place.

After the movie, I went exploring again, this time to the remote Cajon location. To get there, you must turn off a gravel ranch road, and drive about a mile over rutted dirt. When the weather

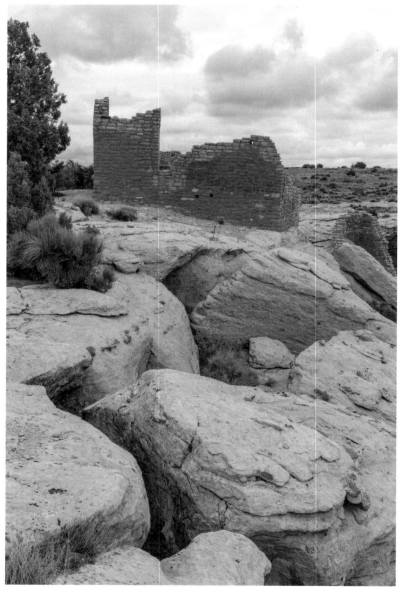

Ruins at the Cajon unit, Hovenweep

is wet, the road can become treacherously slick and impassable. Keeping an eye on the clouds, I drove carefully, and parked in the small lot. I was the only one there.

The site is similar to Square Tower — a number of stone structures, meticulously fitted together; some in better shape than others, along the walls and in a small canyon. Cajon is bleaker than Square Tower, perhaps because there are fewer trees and vegetation to block the desert winds. The threatening sky added to the bleak mood of the place. I walked about nervously for about twenty minutes, not wanting to get trapped along the road in a spring storm. After making a few pictures, I got back in my truck and headed back to camp.

A full day, punctuated by a jigger of bourbon, and a good cigar followed my backpacker's dinner. Camping out of the back of the truck is quite comfortable, even with boxes and gear occupying fully half the space. The foam bunk and a warm sleeping bag soon had me snoozing.

Next morning, the sun popping through the clouds on the horizon woke me early. It was cold and a bit damp. I went about refilling my water bottles, and spent a little time looking at the maps, planning the day's adventure, as I sipped my coffee. Realizing that the clouds were nearly gone, the opportunity to make pictures of Square Tower in warm morning light seemed too good not to take advantage of. Filling my travel mug with coffee, I grabbed my camera pack and the tripod, and set off to

capture some images in the canyon.

The bright, sunny early morning light was well worth the effort. What a difference sun makes to my mood! I walked about two thirds of the way on top of the canyon before the light got too harsh. Around 9AM, I walked back to the truck, and paid one last visit to the park ranger, thanking him for his kind assistance and advice on the Holly trail. Looking at these pictures much later, I realized that my favorites were of the previous days, with the lowering clouds and threatening weather. The soft light does much to enhance the overall mood of Hovenweep, while bright sunshine seems to downplay the importance of this culture's artifacts.

SATURDAY, MAY 11

BEARS EARS

On the road again, I headed for House on Fire, in South Mule Fork. Near the Comb Ridge, documented by David Roberts in his book **"Sandstone Spine..."**, there are numerous instances of ancient Puebloan ruins. House on Fire is oft-visited, and quite picturesque at the right time of day. There is a BLM kiosk just past the turn-off, where you are required to register and pay for a Cedar Mesa day-use permit. The parking for South Mule Canyon is just a bit further down the road. It's really just a wide spot in the road.

Vehicles were parked on both sides of the road at the trailhead, and I knew I'd not be alone. Lucky to find a spot, it didn't take long to find the trail. The morning was still clear and blue, bright sunshine streaming through the trees along South Mule Canyon. The creek had cut its meandering path through forests of cottonwood and live oak. Sandstone walls rose out of the canyon on both sides. Keeping my eyes peeled for signs of the ancients, I peered upward at every possible alcove and cranny.

The trail up South Mule Canyon towards House on Fire

Along the way, I met an older couple with heavy accents. They inquired how far the ruin was. Although I didn't know for sure, I guessed maybe a quarter of a mile further, maybe a half mile. Not far. And then the sound of voices contradicted my uninformed answer. There were a couple dozen folks decamped on a slight incline, waiting for the sun to light up House on Fire.

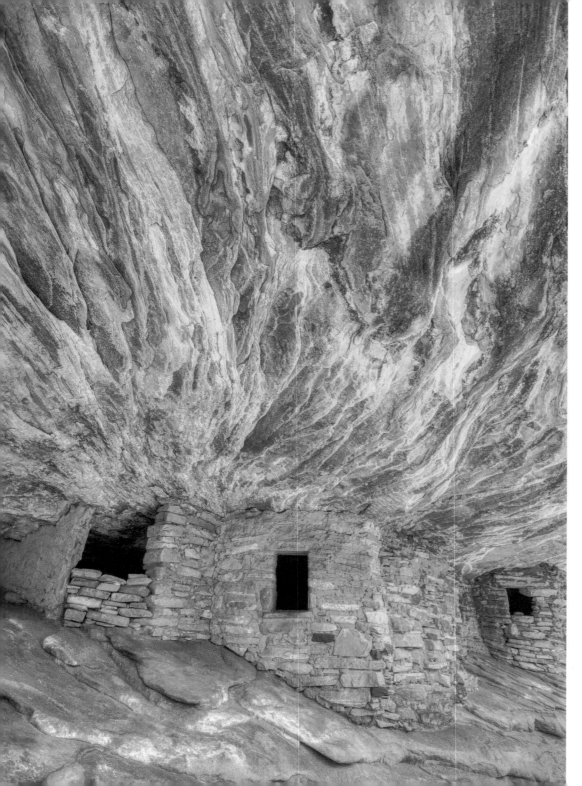

James W. Parker

The German couple followed up the incline, and we gazed at the spectacle in wonderment. It truly did look like a house on fire, with the discoloration of the stone streaming from five small granaries under the alcove. With the sun bouncing off the rock in the front, the streaks in the ceiling above the ruin took on the appearance of smoke and flame.

I spent a good hour making photographs and chatting with the others. It was a happy tourist crowd, having found this wonderful spot. We took turns lying on the rock and snapping low-angle pictures. One man guided me around the corner behind a huge boulder to show me ancient handprints high on a wall, left by an Anasazi artist. Others soon joined us on the rock. I chatted with the German fellow (it turned out they were American citizens from California) about his new Sony mirrorless camera. He was very happy with his Zeiss Batis lens: a fixed focal length prime lens. We took turns lying on the rock up close to make the most of the "flames".

Although there are more ruins further up the canyon, I opted to head for Natural Bridges National Monument. The couple and I both headed back towards the road, hopping over the creek, and following the path of least resistance. Use paths criss-crossed both sides of the water, so it was virtually impossible to get lost. At the road, I bid the couple adieu, and got back on Utah 95 and headed west.

House on Fire, South Mule Canyon, Bears Ears

No one needs to tell you that Utah is beautiful. Along with the geologic features of the Comb Ridge, Butler Wash, Grand Gulch, and Arch Canyon, the rocks and forests of Bears Ears and the Manti-Lasal National Forest are major conservation areas. This is an area that I want to return to and explore.

From the BLM website:

> "The Bears Ears National Monument in southeastern Utah protects one of most significant cultural landscapes in the United States, with thousands of archaeological sites and important areas of spiritual significance. Bears Ears National Monument contains two units, the Shash Jáa unit and the Indian Creek unit. Abundant rock art, ancient cliff dwellings, ceremonial kivas, and countless other artifacts provide an extraordinary archaeological and cultural record, all surrounded by a dramatic backdrop of deep sandstone canyons, desert mesas, and forested highlands and the monument's namesake twin buttes. These lands are sacred to many Native American tribes today, who use the lands for ceremonies, collecting medicinal and edible plants, and gathering materials for crafting baskets and footwear. Their recommendations will ensure management decisions reflect tribal expertise and traditional and historical knowledge."

SATURDAY, MAY 11

NATURAL BRIDGES

At Natural Bridges, I could tell I'd once again entered civilization. The parking lot was full. The camping area had no vacancies, but one of the rangers told me that it was possible to rough-camp anywhere in Bears Ears, along the road, or near it, as long as BLM guidelines were followed. I filed this away in my mind for later. Seeing the major natural bridges was my main objective; the camping conundrum would be solved later.

The geologic formations in Natural Bridges are formed by the action of flowing water over time. The difference between a bridge and an arch is defined on the BLM web site:

> "Bridges and arches are both fragile, natural rock sculptures. Both are formed with water and time, but with different processes. Running water carves natural bridges, while seeping moisture and frost shape arches."

Along the scenic drive through the park, there are overlooks for the three major bridges, Sipapu, Kachina, and Owachomo. Each has its own personality. While the overlooks provide an opportunity to get a glimpse of the bridge, the best way to see the bridges is to hike down to them. So that's what I did.

At Sipapu, the trail drops over the slickrock, and negotiates a couple of sturdy ladders to bring you the valley floor. Sipapu is

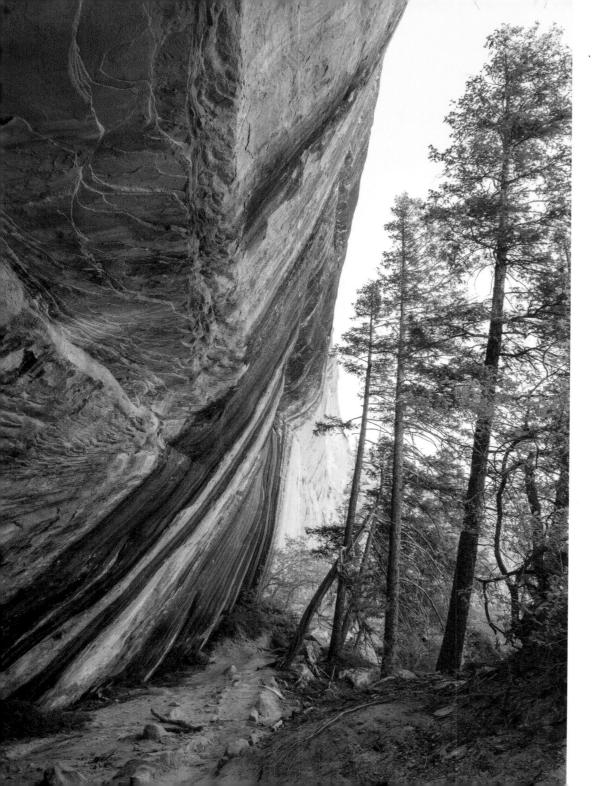

James W. Parker

a solid arch, nestled in the bend of the river as it carves a path through soft sandstone. I didn't take the trail all the way to the bottom. It was mid-afternoon, and I wanted to see all three of the bridges before losing the light completely. Hiking about halfway down the trail landed me on a wide bench, with a good view of the bridge. The Sipapu Trail is strenuous, with several ladders to climb, and a 450' elevation gain/loss.

When I arrived back at the parking lot, the couple I'd met at House on Fire was in the parking lot. We exchanged plans, and it was nice to run into them again. As I got into my truck, I didn't expect to see them on the next trail down to Kachina Bridge. The Kachina trail is about a half mile, with a drop of roughly 350' into the canyon. As it turned out, there were very few hikers on the Kachina Trail. It switchbacks down the slickrock into White Canyon Creek. Once at the bottom, a trail junction gives you the choice of hiking left to a small waterfall, or right, to visit the bridge. The waterfall appeared to be in deep shade this time of day, so I opted for the bridge walk.

As I approached, two hikers were enjoying the water flowing under the bridge, sitting on the rocks beneath it. Always good for scale. I crossed the creek on large boulders, searching for the best vantage point. Kachina Bridge is the youngest bridge of the three, a massive structure.

Hiking out of the canyon was hot work. The wall had a western exposure, and was in full sun. Slow work got me up and out, and on my way to the third bridge, Owachomo. Hiking down the path to this delicate structure, I ran into my new friends from House on Fire. I wish I could remember their names... I'm sure I wrote it down somewhere, but where? We chatted about cameras, and I mentioned that I was considering coming back to shoot the Milky Way from under Owachomo. Natural Bridges was designated the first International Dark Sky Park in 2007. We consulted our iPhone apps for info on moonrise, and Milky Way visibility. PhotoPills is very helpful in figuring out when various celestial bodies will be visible, and lets you simulate how the sky will look at a specific time and location, and save that to your Photos app. On this day, the Milky Way would be visible through the bridge around 4:45AM, should anyone choose to get up and hike down to the spot we had chosen. It was tempting, but that issue of camping nearby was a major stumbling block.

Left: Desert varnish along the trail to Sipapu Bridge

Right: Kachina Bridge. Note the figures underneath the bridge to get a sense of the scale of this massive natural wonder.

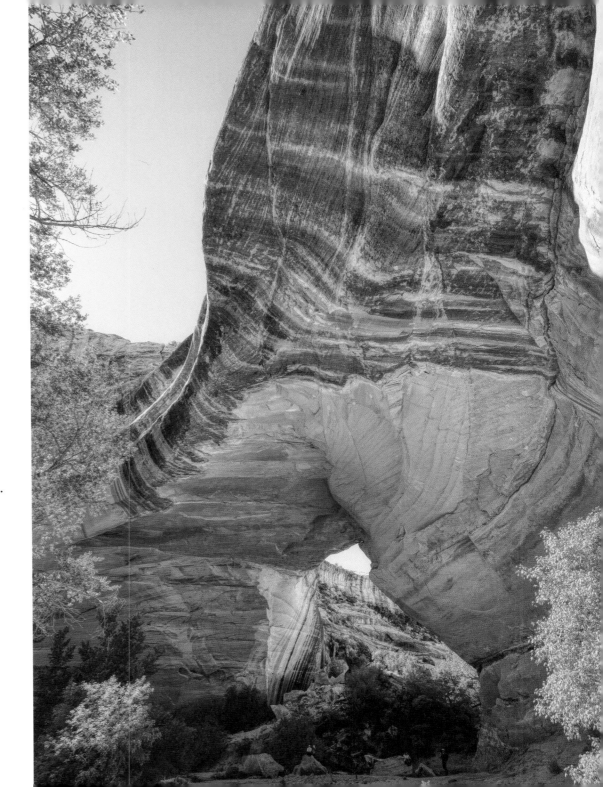

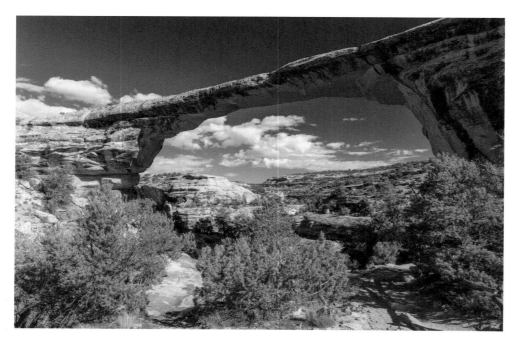

Upper left: Owachomo Bridge. Lower left: spring blooms along the Owachomo trail. Right: Kachina Bridge

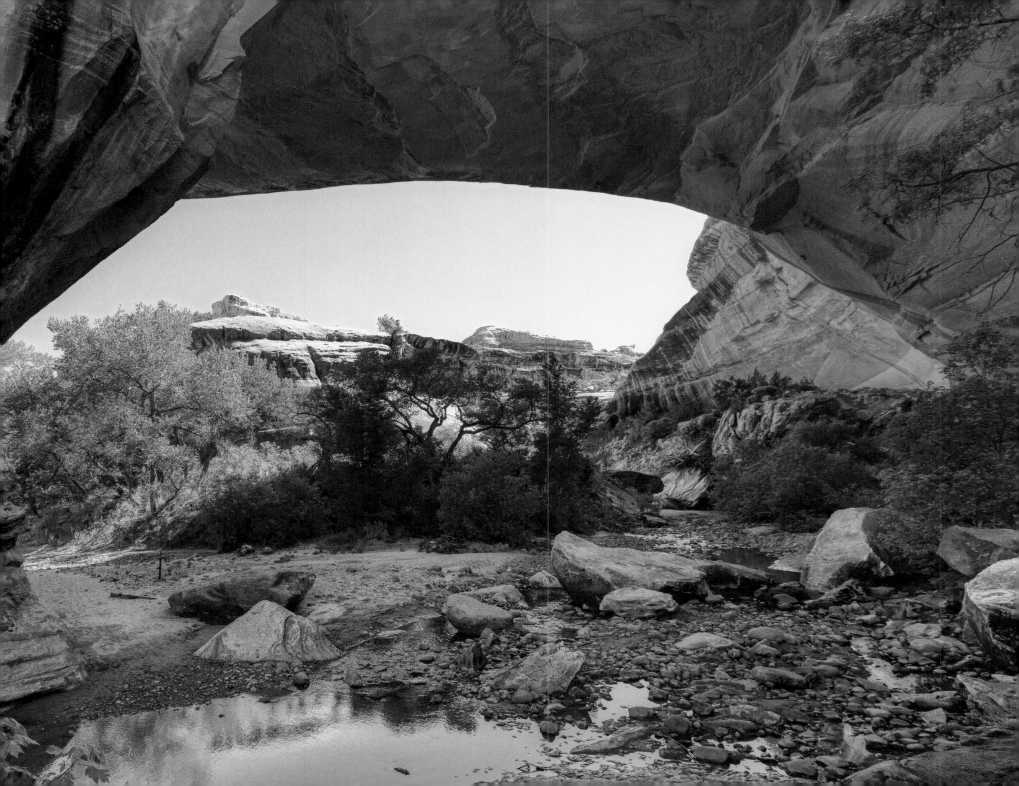

BEARS EARS

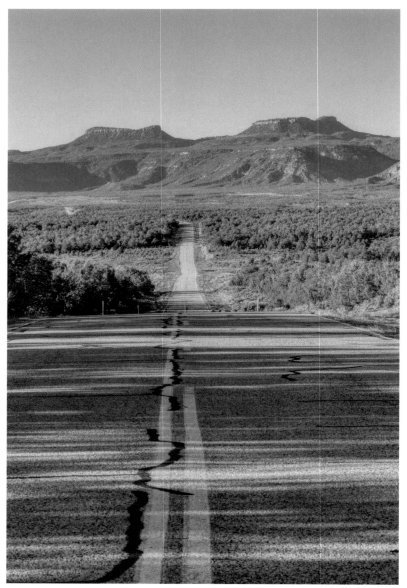

Bears Ears, from the Trail of the Ancients. Opposite: Cedar Mesa at dusk.

After reconnoitering and hiking back out the overlook, I bid my new friends goodbye. I headed back east towards Bears Ears, but I was torn between camping close to shoot the night sky, and heading south towards Muley Point, on the rim of Cedar Mesa and the Moki Dugway.

The Moki Dugway won. A few miles east of Natural Bridges, the Trail of the Ancients runs south, past the Kane Creek Ranger Station. I already had a Cedar Mesa BLM permit, in case I wanted to pull off and camp. Camping on Muley Point is also allowed, although there are no facilities. Passing several turn-offs to points with interesting names, I stopped once to shoot the long view of the Bears Ears. The sun was low in the sky, and I knew that I'd want to camp or get down the Moki Dugway before full darkness. The Milky Way would have to wait for another time.

The dirt road into Muley Point is well-marked. Even though there'd been rain the past couple of days, concerns about impassability proved unnecessary. There were a few deep, muddy ruts to avoid, but generally the road was flat, and good. Clouds on the horizon suggested a possible late evening storm, an event I wished to avoid, as it would have made the road a muddy morass.

Cedar Mesa

Five miles in, it's possible to drive out to the edge of the mesa, and gaze south towards Monument Valley. The view is impressive. But photographically, not tonight. The haze was significant. I decided not to drive all the way out to Muley Point. The clouds on the horizon could be bringing rain. So turning around, I explored the road along the canyon, where there are numerous spots to camp. But it seemed incredibly isolated. Ten minutes of looking at the camping possibilities and thinking about the weather were enough to get me back on the road out.

The Moki Dugway is a famous road. Built in the 1950's for trucks hauling ore from the Happy Jack mine on top of Cedar Mesa to the mill in Halchita, on the other side of the San Juan River, it is 3 miles of gravel switchbacks carved straight into the cliff. My father once remarked after driving to the top of the mesa, that there was no way he was going to drive back down the Dugway. Starting down it at dusk, I didn't anticipate meeting much traffic. A good thing, since the road is barely wider than a large truck. There are places to pull off to let opposing traffic pass, but in general, it's scary as all get out. I'm sure the locals have gotten used to it, as it is a definite time-saver if you're heading towards Blanding or Hite Marina.

Reaching the bottom just as the sun was setting, the view of Cedar Mesa was breath-taking. Off to the left, a road led into the Valley of the Gods. With darkness setting in, and not knowing the territory, I hoped that I would be able to find a hot meal and a

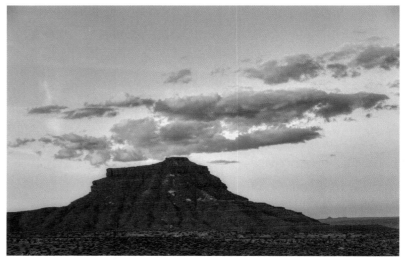

Bell Butte, sunset at the bottom of Cedar Mesa

motel in Mexican Hat, just a few miles down the road. Camping seemed less attractive than a cold beer and a warm bed.

I was in luck. The Mexican Hat Lodge was open, and had some vacant rooms. A quaint, rustic motel, with a pleasant proprietor minding the front desk greeted me. The restaurant next door, the Swinging Steak, promised a decent meal accompanied by a cold brew. Done, and done. Dragging my bags up a flight of stairs, a comfortable bed awaited.

The Swinging Steak lived up to its promise. A large grill swung suspended from chains over a bed of coals, tended by a large cowboy chef. The joint was doing a fair business, always a good sign. I sat at the bar, and ordered a rib-eye. Accompanied by beans and toast, I washed it down with a malty beverage of

some sort. If you are ever in Mexican Hat, I highly recommend this place.

Overhead the stars shone brightly. A bit of a chill was still in the air as I headed up the stairs to my temporary home. I was soon sawing logs in the cozy bed.

SUNDAY, MAY 12

OLJATO

The next morning was crisp and clear. The kitchen at the Swinging Steak was not open for breakfast, and the front desk was closed up tighter than a drum. Rather than hunt for a breakfast cafe, I lowered the tailgate on the truck and fired up my little camping stove for the morning brew. I use a little AeroFlow coffee maker with pre-ground Starbucks, and it works pretty well for car camping. Too bulky for backpacking, it's a nice luxury on the road. Coffee made, I headed south towards Monument Valley.

Crossing the San Juan River, the road darts south. At the top of the hill, Halchita is a small settlement of trailer homes and ce-ment block structures. Highway 163 is famous for one stretch between Mexican Hat and Monument Valley, known as the ***"Forrest Gump Spot"***. Several turnouts feature abandoned Navajo jewelry stands and offer a viewpoint of Monument Valley that stretches down the hill for about five miles. This is where

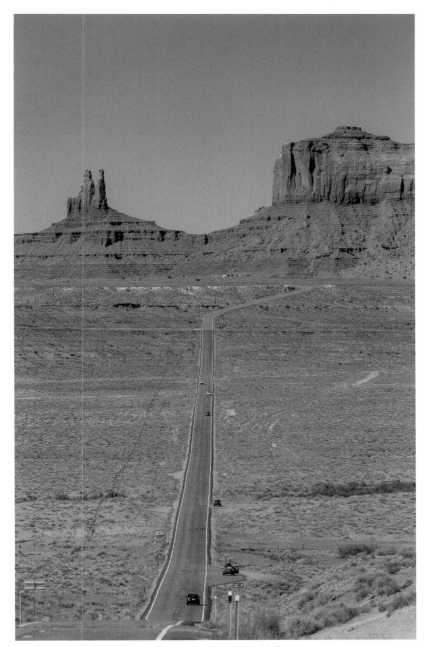

Highway 163, looking south towards Monument Valley

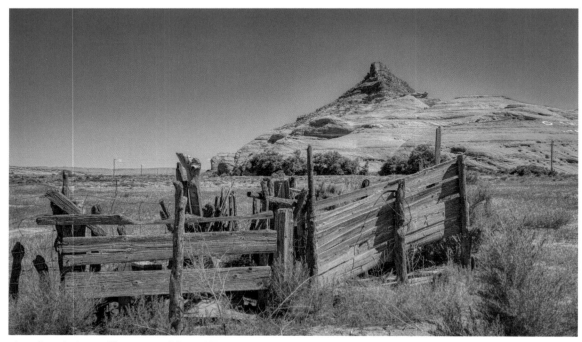

Oljato Trading Post ca 2009

Loading chute, and butte near Oljato, UT

Forrest Gump finally stopped running in the movie of the same name. When I was here ten years ago, I was the only one who stopped. Today, there are dozens of cars, campers & RVs parked. Tourists run out to the middle stripe to shoot the scene, while keeping a wary eye for oncoming traffic. I was more interested in revisiting the little town of Oljato, Utah.

The Navajo Trading Post in Oljato has been closed for many years. When I camped in Monument Valley on my last visit in 2009, it had already been deserted for a while. My photograph "Orange Door" was still there, but the door was the worse for

wear. I was wandering around the building making pictures, when a pickup truck drove by. The driver stopped, to make sure I wasn't trying to steal something, probably, and we got into a conversation. His wife had grown up in Oljato, and they were taking the grandkids to hike among the sandstone bluffs a few miles away. After the kids got antsy, and he drove off, I made a few more pictures that I had missed the first time around. Back on the road towards Monument Valley, I didn't feel any compulsion to see it again, so I headed back to Mexican Hat. The Hat Rock Cafe across the bridge looked good, with a number of trucks parked out front. The hostess welcomed me to a busy

restaurant with a menu of Mexican entrees and American standards. I chose a burrito with green and red sauce, and it was damn tasty. I washed it down with a brew, and headed back towards the Moki Dugway.

VALLEY OF THE GODS

Rather than retrace my steps back towards Bears Ears, I decided to check out the Valley of the Gods. From 263 below the Dugway, a gravel road connects with Utah 163, winding its way 17 miles through Road Canyon Wilderness Study Area. Like most of the BLM managed areas in Utah, camping is allowed anywhere you can pull off the road. There are no facilities, however, no water, no pit toilets and no reservations. I saw quite a few campers and a couple large RVs, as well a number of mountain bikers, both along the road, and off-road.

The formations in the area are equal to those in Monument Valley, without the crowds. It was obvious from the number of people camped here that it was well-loved by the locals, and a well-kept secret. Every turn revealed new formations, with names like Sitting Hen Butte and Lady in a Bathtub. Since I was due in Moab later that afternoon, I was sad that I couldn't spend more time during golden hour. This is definitely a place to return to camp, and enjoy some astrophotography.

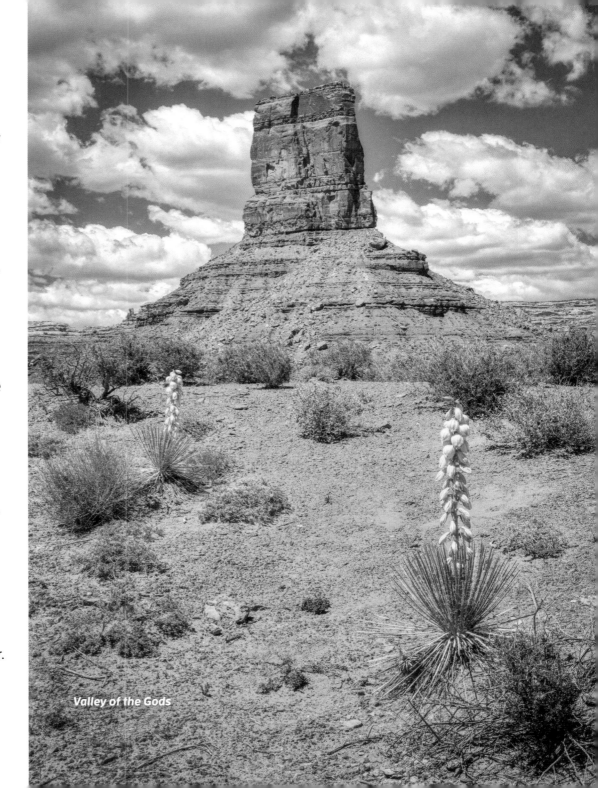

Valley of the Gods

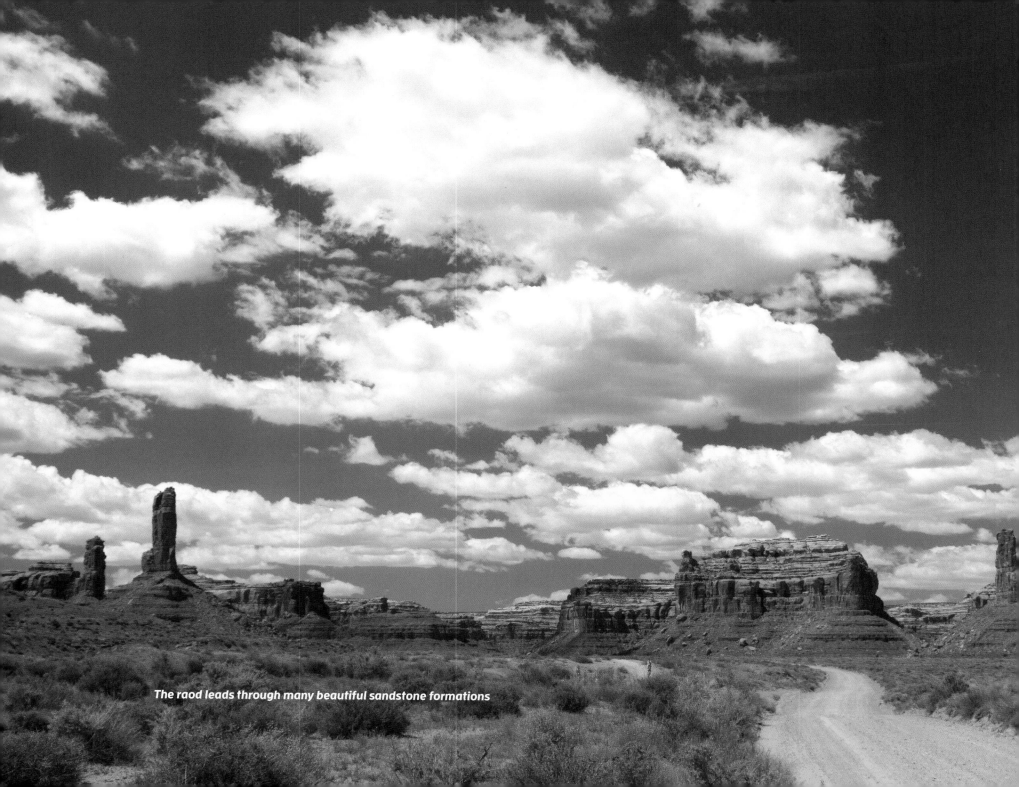

The raod leads through many beautiful sandstone formations

Wislon Arch

SUNDAY MAY 12 - TUESDAY MAY 14

MOAB

After a thoroughly enjoyable tour of the sandstone spires and buttes in Valley of the Gods, I reached Utah 163, and turned north toward Bluff. Bluff is well-situated for staging southern Utah explorations, along a scenic stretch of the San Juan. Past Bluff, a junction leads towards Blanding and Moab. I stopped twice, once to photograph Church Rock, and a second time at Wilson Arch. I was amused at Wilson Arch by a female OTR trucker who was watching a family scramble up to the arch. She herself was afraid of heights, but was definitely not afraid to comment on those less fearful!

Late afternoon sun saw me swinging into Moab, a full-fledged tourist town, with Jeep and ATV rentals, expeditions to suit every adventurous spirit, and a five mile strip of hotels, motels, restaurants and outdoor outfitters. The Comfort Inn and Suites was at the north end of town, past the pleasantly touristy downtown area. I checked in with no issues, and lugged some of my gear up to the room on the second floor. Beasley wasn't scheduled to arrive until later that evening, so I got unpacked, and went in search of a good meal.

The desk clerk recommended Thai Bella, a couple of blocks away: an easy walk. It lived up to the hype. Quiet, authentic, with delicious food. I ate, and got back to the hotel as dusk was falling.

Around 9:30, Jim Beasley made it. He drove up from Santa Fe, where he and his wife, Lynne Bryant, had a large RV parked for a few weeks. Jim and Lynne have been full-time RV'rs for a couple of years now, and Jim arrived in a Ford F-450 with a huge auxiliary gas tank in the back. We exchanged manly hugs, Jim hauled up some gear, and soon we were sawing logs.

After a few days of sleeping in the back of the truck, the Comfort Suites in Moab was like heaven, even with Beasley snoring in the next bed over. We got up, farted, and did our usual morning stuff before heading down for the breakfast buffet. Good stuff: there was yogurt; cereal; apples, oranges and bananas; eggs and some kind of mystery meat; packaged peanut butter and honey for bagels; and decent coffee. We fueled up, and got

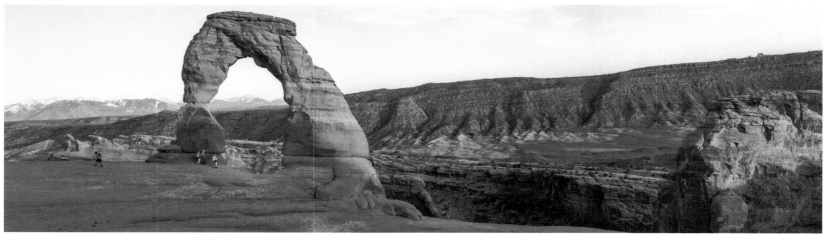

Delicate Arch, sunset, from 2009

out the door around 8:30 and headed up the highway towards Arches National Park.

It's good to do Arches early in the day, as the entrance kiosk queue fills up fast. Once the cars reach out to the main highway, US 191, the rangers don't allow more cars in line. And the popular attractions can get busy. We didn't have much of a wait, and our Senior Passes got us in for free. Jim didn't have a burning desire to see Arches, which I found a bit surprising, but it is a popular, over-photographed tourist destination.

We drove up to the Devils Playground, and found the parking lot almost full at 9AM. Loaded up our camera packs, put on our hats, stowed our water bottles. Walking up the trail towards Landscape Arch, there were lots and lots of people. The path is hardened, and already the light was pretty harsh. I felt that it was worthwhile to at least let Beasley have a taste of the park, so we made a half-hearted attempt at shooting some pictures. Jim

used his Sony point & shoot (He brought several cameras on this trip. A Sony with an extended range lens; a small point & shoot; a Sony A9; and a Sony A6400).

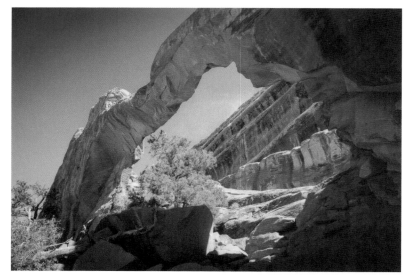

Main Street Arch, in the Devil's Playground. Gone, but not forgotten. 2009

Past Landscape Arch, we discovered that the trail I was familiar with had been altered, due to the collapse of Main Street Arch a few years ago. A friction walk up a steep fin gets you within viewing range of the Navajo Arch. It's a traffic jam, and not particularly safe, as a slip could send you off the fin twenty or thirty feet on either side. We opted to get the hell out of there. I'd walked this trail before, and Jim had no burning desire to do it, either.

Next stop was the obligatory visit to Delicate Arch, the geologic icon featured on the Utah license plate. Rather than hike the two miles up to the arch itself, we went around to the back side and walked up to a viewpoint across a deep ravine. Quicker, fewer people, and Jim could claim to having seen Delicate Arch. Hot, and getting hotter by the minute, the view is worth the twenty minute hike up. After passing a geology class on the rim, we saw almost no one at the top of the hill. Jim had little interest in making any photographs in the bright sun, and I had to agree with him.

We skipped Balanced Rock, North & South Window Arch, Double Arch and all the rest, and headed back to Moab for lunch at the Moab Garage. After lunch, one of many trips to Moab's prime expedition suppliers: Gearheads! A backpackers/climbers/rafters paradise, Gearheads has just about anything you might want. I don't remember exactly what I bought on this trip, but we went back for more stuff at least half a dozen times. We stopped at City Market to pick up a couple of food items, and drove back to the hotel.

The author, hiking in Arches. Photo: Jim Beasley

Much of the rest of Monday, and most of Tuesday was devoted to hauling our gear up to the room, sorting it and determining what we needed and what we could leave behind. There was a

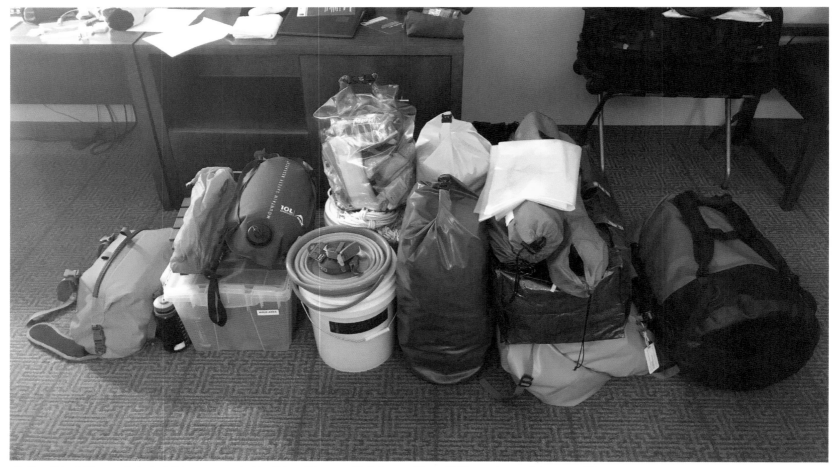

It doesn't look like much, but all this gear needed to fit in a 17' canoe. Not shown: Three 18 liter water containers and the groover.

lot of equipment. Each of us brought our own tent, sleeping bag and pad, clothing, personal hygiene, and the like. We both had Garmin satellite communication devices. Jim brought two, as Lynne insisted he have a backup, although I think the backup got left behind. There were camera bags to sort through, and food decisions. I had brought my trusty MSR Whisperlite International, with a full complement of field parts and several fuel bottles. We both had iso-butane stoves as backup, and for quick meals. Beasley brought two water-tight food-safe buckets, which solved one problem, carrying the stoves and fuel. We both had

cooking pots of various sizes and shapes, which got pared down to one basic MSR Alpine set and a Coleman pot with the spare stove in it. The other barrel had Jim's lunch and breakfast food; I had a big plastic crate with all the dehydrated supper meals, and two smaller bags with my breakfast and lunch in them. There were two folding camp chairs and a tarp. There were tripods. There were two MSR Dromedary water bags, one 4L and one 10L. Yes, we had too much stuff.

Tuesday was punctuated by more trips to Gearheads, a nice lunch at Fiesta Mexicana, another trip to Gearheads, more gear sorting, and a trip over to Tex's Riverways to ask questions about the gear. We had a look at the canoe, arranged to rent one of their dry boxes and three big water tanks, and inspected the "groover". Then, dinner at Thai Bella, and more gear sorting.

Tuesday evening, we finally had our gear packed, and ready to go. We lined it up in the middle of the room, and measured it end to end to see if it would fit into the canoe. It seemed do-able, although we still had the three 7 gallon water jugs and the "groover" to fit into the space. The "groover" is a portable toilet system, rented from the outfitter, about 15" on a side, and required for any backcountry river trip. I had one big Bill's dry bag with all my equipment, and a nice Watershed Ocoee Dry Bag for my camera and power. Beasley had three dry bags, and a somewhat waterproof IKEA duffel. I had no idea what all was in each of them, and politely suggested leaving less essential gear

behind. But Jim was unable or unwilling to pare his gear down. I was quite dubious that all this "stuff" was going to fit in our 17' Grumman canoe and still leave us maneuverable. A prescient observation, in hindsight.

We took most of the gear downstairs and loaded into the back of the Tundra. About 11:30PM we called it a night, and tried to quell the butterflies in our stomachs, as we drifted off to sleep.

DAY ONE - WEDNESDAY MAY 15

MINERAL BOTTOM TO FORT BOTTOM

Wednesday morning we were up early. We grabbed some peanut butter and bagels from the breakfast buffet, moved our camera gear to the trucks, and checked out of the hotel. The drive over to Tex's was just a few short blocks, and we were there early. I found out that I needed more cash than I had to pay for my share of the shuttle service and rentals, so I got back in the truck and found a gas station with an ATM. (Tex's is a cash-only business.) The shuttle, canoe and equipment rentals ran each of us about $375. We pulled the gear out of the trucks, and waited for the shuttle to arrive.

By eight, the parking lot was buzzing with activity. More cars pulled in, and young people started unloading gear. Geddy, one of the Riverways workers, pulled up with the van. The twelve-

all stowed underneath the canoe racks and strapped down. Hopping in the van, we headed north out of Moab, towards the Mineral Bottom put-in. The crew was efficient, but it still took an hour or so to get everybody and everything loaded up.

The trip to Mineral Bottom takes about two hours. The first stretch runs up US 191, to the turn-off for Dead Horse Point, at a dinosaur attraction. The road is paved for the first half-hour or so, until the turn-off for Mineral Bottom.

With the Henry Mountains in the far distance, we thundered along the red dirt road with the canoes in tow. Occasionally passing a truck going in the opposite direction, the road was just barely wide enough to let two vehicles pass. During good weather, the road is decent, but rain can make these desert tracks impassable very quickly. Luckily for us, the sky was blue, and there was little rain in the forecast. Beasley, sitting in the front seat next to the driver, kept a steady stream of conversation going, in between descriptions of the passing scenery.

The last half mile descends the Green River canyon abruptly. Many times, the van will stop to let the riders take pictures of the precipitous drop before making the trip down, but not today. We were running a bit behind, and there were a lot of us to get launched, so Geddy made the turn. Quite amazing that the guides are able to get a full size van and a trailer around the tight corners and even more amazing that no one was coming up the other way. I tried taking pictures out of the window, but had little

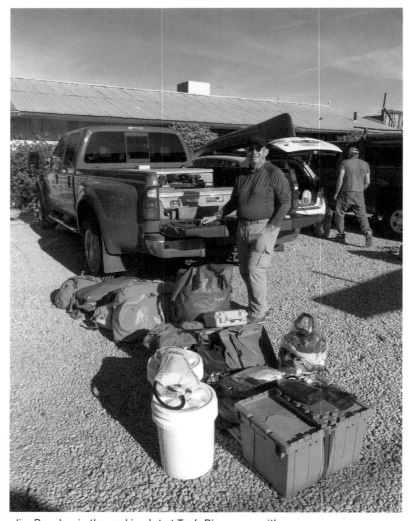

Jim Beasley, in the parking lot at Tex's Riverways with our gear.

person van had a trailer hitched to it with half a dozen canoes stacked on top. We started ferrying gear to Geddy. Soon the dry bags, water jugs, groovers, and other paraphernalia was

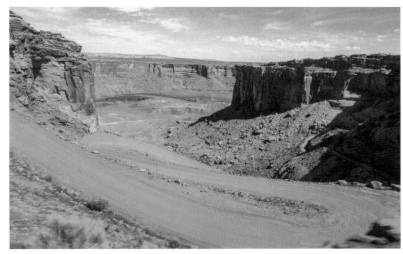
The road down to Mineral Bottom

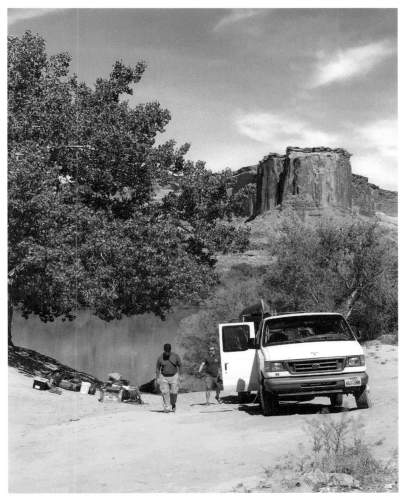
The put-in at Mineral Bottom was pretty muddy

luck in capturing the frightening experience. The road had been blasted off the side of the canyon with dynamite by ranchers, to allow access to the river. It's one of the few places on the Green that can actually be reached by a vehicle. The ranchers used the road to move cattle from the bottom to the mesa for grazing purposes. Kelsey's book describes much of this history in detail.

There were a couple of bicyclists riding uphill on the canyon road, finishing the tail end of the White River Rim Road. We could see the sag wagons at the put-in, and I thought to myself that this would be nigh to impossible for me. Beasley thought it would be a great ride, as he is an avid cyclist.

At the river, we all pitched in to unload the canoes and the gear. Mineral Bottom is both the put-in for the last 52 miles of the Green River, and the take-out for those coming down from Ruby Ranch. Beasley and I slid our 17' aluminum canoe down to the water's edge. Methodically loading our 2 tons of gear, I was glad I brought extra long lash straps and bungie cords. Miraculously,

everything fit, but the canoe looked like the Beverly Hillbillies go to Utah. Mud about a foot deep made it tricky to get the craft into the water. We put on our PFDs and grabbed a paddle. The Riverways guys gave us a hand, and I slid into the stern and held the boat steady, while Beasley stepped gingerly into the bow from the bank on the right. And we were off.

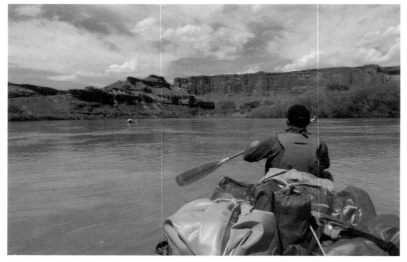

On the river at last.

The boat settled solidly into the current. We shifted gingerly, and each motion was amplified by the boat. Experimenting with steering the boat, we tried to find a rhythm that kept the boat on an even keel, and kept us pointed downstream. The current was fast, and pushed us along. After twenty minutes or so, we started feeling a little more comfortable. The river constantly revealed itself to us with each bend. Tamaracks and willows lined both banks, and red cliffs rose up on both sides. I tried making pictures

with my Lumix, but every time I took my paddle out of the water, the boat would swing with the current. I didn't have a lot of time to get the camera out of its dry bag, compose, focus, and shoot, before having to quickly dip a paddle in the water, and correct our course. We must have looked like crazy drunkards, careening back and forth across the river.

I was also trying to manage the maps, and keep tabs on our location. We had an abundance of trip beta, in paper maps, and on our electronic devices. Jim had mapped every significant mile marker and waypoint and we had imported that data into GAIA as well as bringing it into Earthmate, the navigation app that the Garmin GPS systems use. It was difficult to use the phone while paddling, however. I had the same issue with the phone as I did with the camera. Open the dry bag, get out the device, type in the password, get the app centered on the location, try to determine what part of the river we were near. The Trails Illustrated maps were easier to manage in their "waterproof" map case.

We relaxed, and paddled along. The sun was bright. Marveling at the gorgeous geology, it seemed like paradise. We were among the last to leave to Mineral Bottom, and we had the river to ourselves. Soaking up the experience, it seemed as if we could just float all day. And then we rounded a corner, and the wind came up, blowing straight into our faces.

Paddling against a stiff upstream wind was a bit more work. We put our backs into the work, and stroked downstream. On the

Green, afternoon typically brings a strong wind, so the guides recommend an early morning start, and getting off the river in the mid-afternoon to enjoy some quiet time in camp, or exploration on foot. I kept an eye on the map. Near Taylor Canyon, we saw a 4WD vehicle cruising slowly along the White Rim Road. That trail is pass-

The White Rim 4WD trail comes right down to the river's edge in places.

able to experienced drivers, bicycles and motorbikes, but ATVs aren't allowed. There are a number of backcountry campsites along that road. The full trip can take two days, or more.

Our first stop, Fort Bottom, had an old ranch cabin and a moki fort atop a thin mesa extending into the river. We

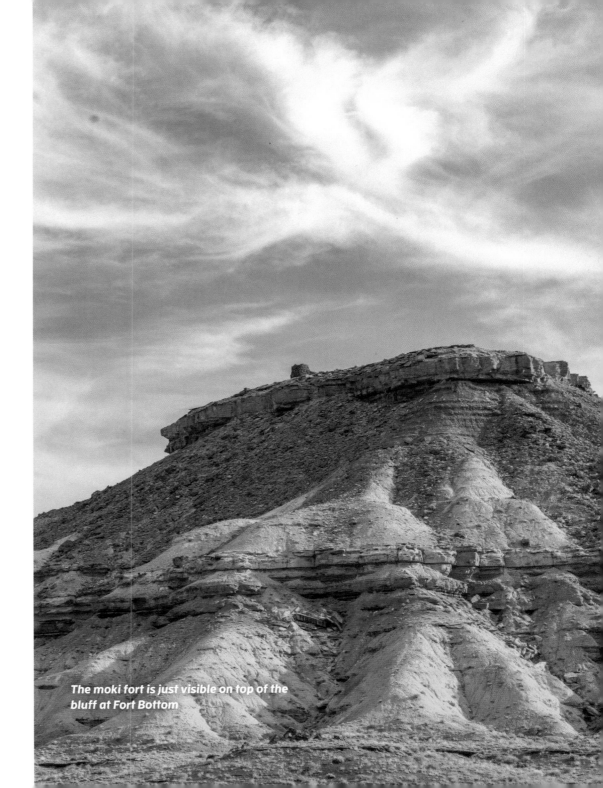

The moki fort is just visible on top of the bluff at Fort Bottom

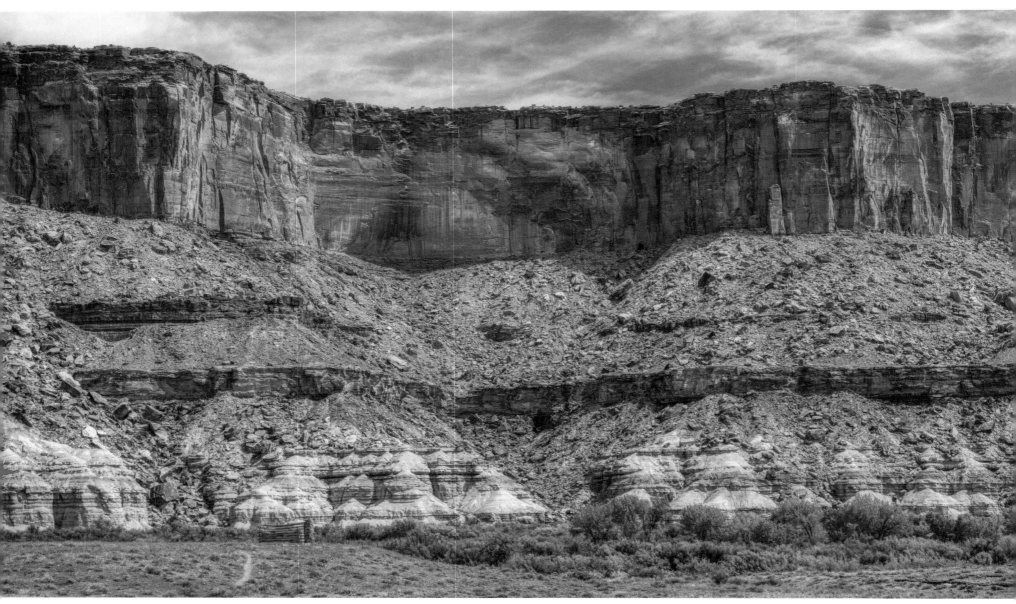

The mesa towers over the river at Fort Bottom. The Walker Cabin is visible by following the path at lower left.

kept close to the left-hand shore, both to stay out of the wind, and to be able to get into the landing when it appeared.

And appear it did. A tiny opening in the tamaracks on the left. We came about quickly, and managed to turn in. A rock ledge and a sketchy path led up to higher ground. The water was shallow here, and reeds were interspersed in the cove at its end. We anchored the boat, and took a look at the potential campsites. Definitely the right spot, but a bit of work ahead of us to unload the gear and get it up the steep trail.

Beasley brought out his 50' cable, and we tied the boat to the strongest trees we could. There was just enough rock to offer secure footing, and we ferried our gear up to the camping area. I took a look around, and found a good flat spot, above a dry wash. Beasley picked another spot a bit away, and there was a nice overhanging rock for cooking. Jim took the groover off along a side path, and found a semi-private spot to park that device.

We spent the next hour setting up camp, under a lowering sky. Another group of canoeists arrived while we were working. Somehow, they had managed to get landed in the swampy end of the cove. One of them told us that they weren't planning to stay, although there was plenty of room. They headed off in the direction of the moki fort. There were several canoes in the cove, including one beautiful wooden single person craft. We kept at it, and soon our camp was home. As we were finishing up, the group came back through camp, and bid us farewell.

We took a short hike over to the abandoned cabin. The desert was in full bloom, with flowering prickly pear, small blooms everywhere. Both of us brought a camera, although the light was flat. Getting the lay of the land, and celebrating our first successful day on the river, we high-fived. I don't remember which of the

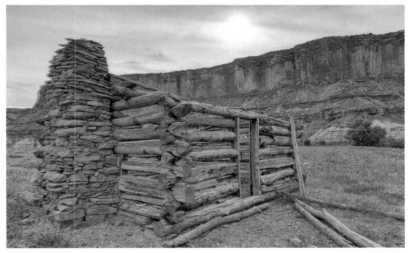

The Walker cabin at Fort Bottom

dehydrated meals we ate that night, just that there was a LOT of it. I was quite generous with the portions. Always over-estimating the amount of food a hungry camper needs, we ate about half of dinner, and stowed the rest in a zip-lock.

There were no stars that night. Too cloudy. We were exhausted from the adrenaline rush of two days worth of packing, the ride down to Mineral Bottom, and the exhilaration of actually landing the canoe successfully. Both of us slept well enough, although

sitting in the canoe brought on some leg cramps mid-way through the night.

I was glad that I brought my extra-cushy REI Air Rail mattress. Too bulky for backpacking, this luxe item fit nicely into my huge Bill's Bag, along with a pair of hiking shoes. I had brought my Osprey Mutant backpack packed tightly with my standard camping gear, anticipating a night camp up on one of the mesas. Everything in the backpack was packed in smaller dry bags, and the backpack packed into the big dry bag. This system was about to get tested on our next day's journey.

DAY TWO — THURSDAY, MAY 16

FORT BOTTOM TO ANDERSON BOTTOM

Up early to a bright sunrise next morning. Breakfast for me was a big mug of coffee and some oatmeal. Beasley favored peanut butter and graham crackers. We got organized and broke camp. I convinced Jim that a quick hike to the top of the mesa to see the Moki fort was in order.

We grabbed cameras, water, and some protein bars. The walk was well-defined. Up a small hill, and then a short climb to a steep little scramble and we were on top. The view of the Green was impressive from here. A short round Ancient Puebloan tower stood watch over both approaches from the river. A stem

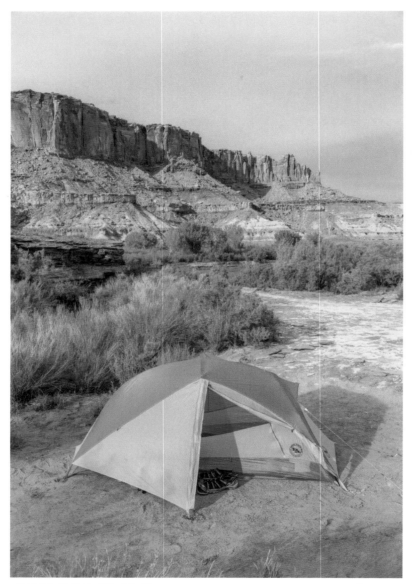

Good tent sites at Fort Boittom

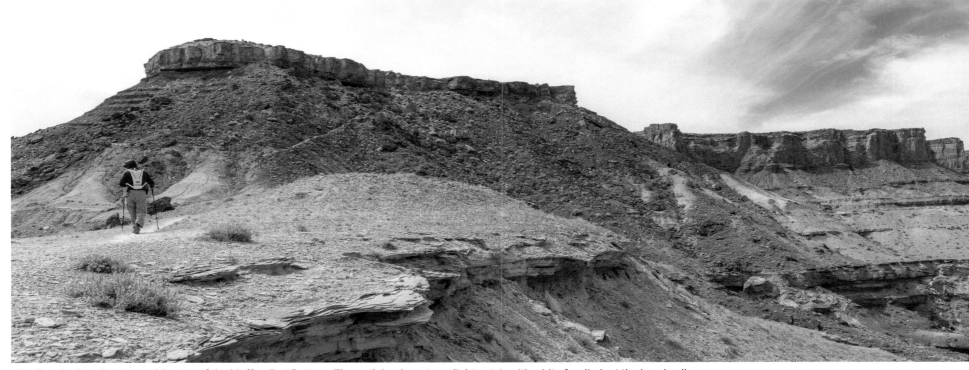

Jim Beasley heading toward the top of the bluff at Fort Bottom. The path leads up to a slight notch with a bit of a climb at the headwall.

trail led off towards the White River Trail, and civilization.

One of the main reasons to paddle the Green River is to view geologic time up close. Although I did quite a bit of reading before the trip, being there is a whole different ball game. The cliffs and buttes rise up next to you as you drift downstream in a never-ending vista. At the top of Fort Bottom, we could see the river curving into infinity in both directions. I don't recall any- thing about what layers we saw, or what age they represented.

I just remember being awestruck about 101% of the time. David Day's book, "**Canyonlands National Park Favorite Hiking and Jeep Trails"** has a very concise description of the geology of Canyonlands. I had it on my Kindle, on my iPhone, and I read it several times.

We both had copies of Belknap's **"Canyonlands River Guide"**, a compact, waterproof map and history guide. Belknap's also has a very good color illustration of the various strata, and indicates

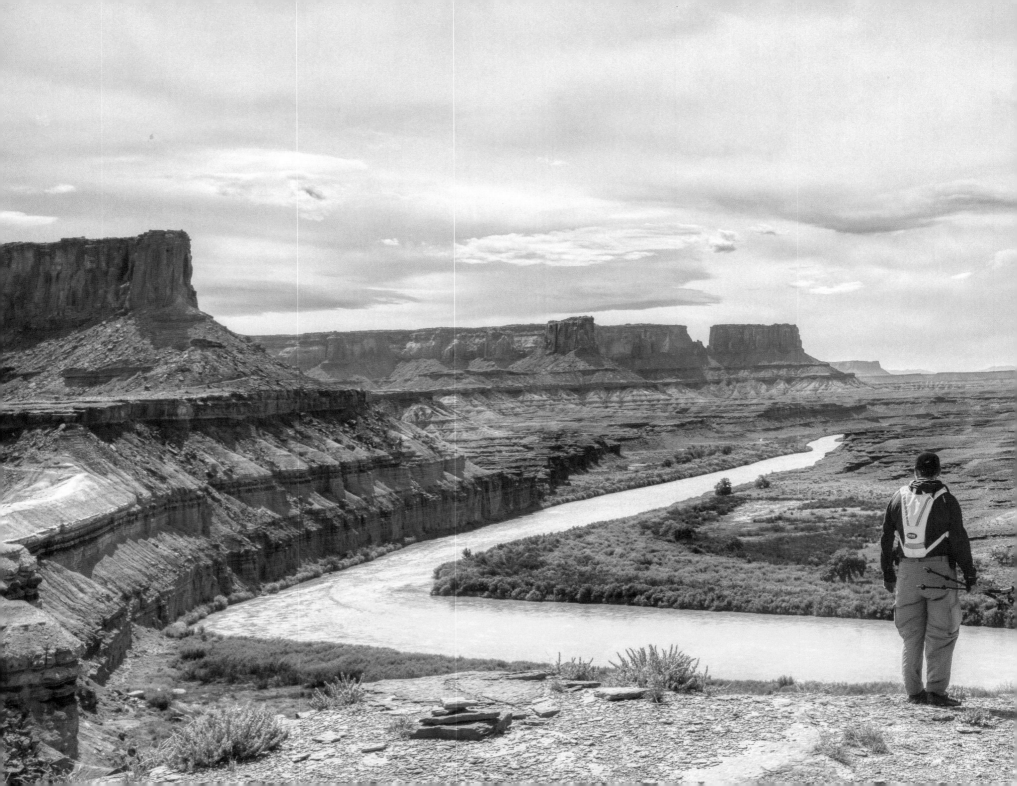

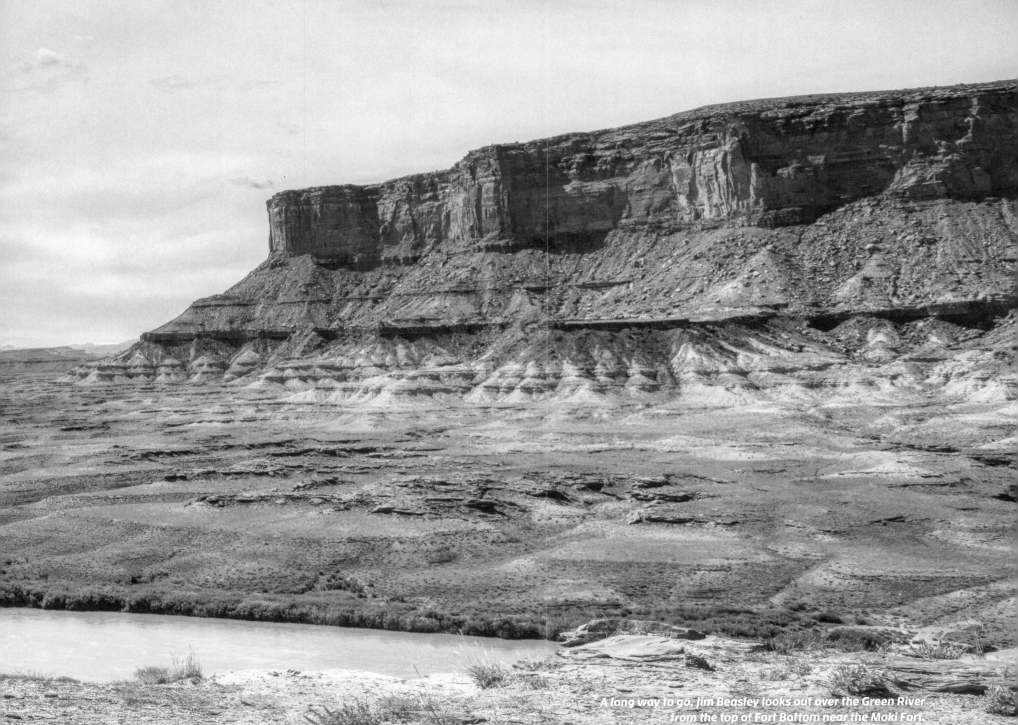

A long way to go, Jim Beasley looks out over the Green River from the top of Fort Bottom near the Moki Fort.

where each type of rock occurs along the river. All this information still didn't stick. The reality was that the beauty of this place is so overwhelming that all I could do is look and absorb, take pictures, and be thankful.

The river makes a huge loop around Fort Bottom. Looking downriver, we could see Tent Bottom, and Tower Park in the distance behind it. Behind us, to the west, we saw steep cliffs of Moenkopi sandstone. Today's journey would take us slowly downhill through layers of geologic time, into the Permian Period. Downriver from where we stood, the White Rim would slowly appear out of the water, until it towered above the river.

On the way back to camp, I detoured to make a few photographs of the Walker cabin in the morning light. Last evening, clouds had mostly softened the light, and I was looking for a bit more drama. Beasley headed back to the camp, to break down his tent and pack the duffels. I took a few minutes to savor the stillness, the desert blooms, and the peace of this place.

Our gear safely packed and secured in the canoe again, we pushed out into the stream. Today's destination: Anderson Bottom, about ten miles down river. The river was very high, and running fast. We anticipated that it would only take a couple of hours to make it to Anderson, where a couple of different landing options offered opportunities for hiking up onto the Millard Benches for a first hand look at the Buttes of the Cross. As one of the main objectives for this trip, the Buttes had captured our

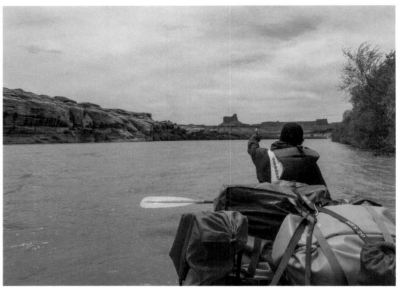

Our first sighting of the Buttes of the Cross

imagination, just as it had captured John Wesley Powell's imagination 150 years earlier.

Even though we had tried to get on the river early to avoid the mid-day winds, we soon encountered a stiff breeze blowing upriver. Straight into our faces, we paddled steadily, always keeping the boat close to one shore or the other. The river is wide in this part of Labyrinth Canyon, and there were lots of tamarisks and willows along the banks. The sky began to cloud up again. Two or three miles downriver, we had our first sighting of the Buttes of the Cross. Both of us tried to get a picture from the river, but the current kept swishing us about, so it was hard, especially with a tiny little point and shoot.

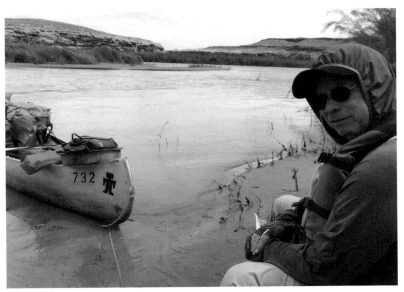

Lunch at the Mud Bar

At Mile 37 or so, the White Rim starts to appear. At first, the white sandstone is at river level, near Potato Bottom. When the river is low, this section often has numerous sandbars, and places where a canoe can land. We kept our eyes open for such a place, to stretch our legs, and perhaps have a snack. It was getting past my lunchtime! Plus it's impossible to stand up in a canoe and pee, especially when loaded down with 400 pounds of gear. As the canoe approached the big sandbar near the outlet of Millard Canyon, Beasley suggested we try to put-in there. We steered into the narrow channel, and paddled upstream to Millard Creek. The water was shallow here, no more than a foot deep. The bottom seemed sandy to me, but the end was a good 100 yards away. It didn't seem like a good idea to get out and line the canoe

all that way, so we opted to turn around and try docking on a small sandbar at the mouth of the creek.

This proved to be a bad idea. We came out into the river, and turned the canoe's bow into the bank, and I kept a paddle in the water. Jim tried to get out of the canoe, and got one foot into the water. As he transferred his weight, his right foot sank thigh-deep into mud, and he lost his balance, taking the canoe with him. With so much weight in the boat, it was easy to tip a gunwale into the water, and then it filled to the top.

We took the food barrels out of the canoe, and ferried them with some difficulty to the mud bank. Finding a more solid spot, I tossed Jim the two camp chairs and the tarp. Jim grabbed his camera dry bag and some other smaller gear from the bow. Deciding that we didn't need to unpack the entire canoe, bailing seemed the next best option. Tex's had provided us with a rudimentary bail bucket, and a sponge, but this of course was fairly useless. The bail bucket was nothing more than a half gallon jug with the bottom cut off, crushed into a flattened shape from years of use. I pulled out the 10-liter collapsible bucket I had brought to settle river water for drinking, and this proved to be a much better bailing tool.

Getting the canoe emptied out took a while. We both struggled with the muddy bottom. Luckily, it wasn't so muddy that Jim couldn't break his feet free, but it was an effort. With the food buckets on shore, it was time for lunch. I broke out a bag of tuna

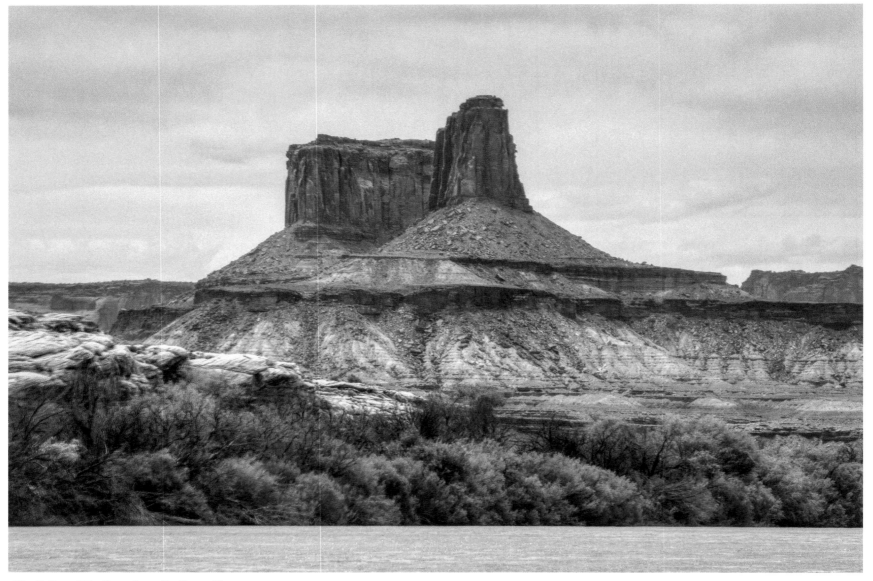

The Buttes of the Cross from the Green River

and some pita pockets, which luckily had survived this dunking, and made a tuna sandwich of sorts. Jim ate a couple of protein bars. We sat on the food barrels, which kept us out of the mud, sort of, and laughed about this silly mishap.

Lesson Number One: always check the bottom.

We got the canoe loaded back up without further mishap. We managed to get ourselves into the boat without dragging too much mud along with us, and gingerly pushed off into the current. Floating down the river, the wind was still in our faces. Only three miles or so to reach Anderson Bottom. Our eyes were peeled for landing spots. Recent experience had taught us that landing the canoe was the most difficult part of the journey.

The White Rim was now over our heads as we traveled down the river. Somewhere in front of us was a large boulder, with names inscribed on it. With the river as high as it was, there was no way we'd be able to cruise into the little cove next to it to see them, and still get across the river to land at Anderson Bottom. Up ahead, we saw a group of canoes tied up along a steep bank. The first Anderson Bottom landing. But there was no room for us to land there, with six or seven canoes already moored. It didn't look that easy to get up the bank with all of our gear anyway, so we kept paddling downstream.

We stayed close enough to the right hand shore to make a turn if necessary. The tamaracks lining the bank presented an impenetrable wall. From his research, Jim knew that there was another tributary joining the main flow. Suddenly, there it was. We turned upstream to enter it, but the current was fast here. I wasn't able to get us pointed upstream quickly enough, and the river swung us into the tamaracks on the downstream side. The canoe flipped over, dumping us both into the river.

I went underwater. When I came up for air, two paddles were floating downstream next to me. I grabbed them with one hand, and grabbed for the bushes on the left. The river tried to sweep me along with two of Jim's little water bottles that were cast free, but I managed to hold one. I yelled to Jim, "Are you ok?"

Beasley replied, "I have the boat, but I can barely touch bottom here." It was muddy, not as muddy as Millard, but still knee deep. He had managed to keep the canoe from getting away, but was holding a bush in one hand, and the boat in the other, while trying to maintain his footing in the river.

I had to go hand over hand along the bank, and under a very low hanging limb to get back to the canoe. It was maybe ten feet upstream, but it was a struggle. Fighting the river and the tamaracks, it took me five minutes to get back to the stern. It seemed like a lifetime. I was able to use the stern line to haul myself up over the gunwales. Even filled with water, the boat supported my weight.

Reaching for the orange collapsible bucket, the bailing process began. Again. I thanked God for the foresight to bring a bucket.

It made emptying the canoe so much easier, but it still took a while. A canoe holds a LOT of water. Once the canoe was mostly empty, we were able to drag it upstream into the calmer water of the little tributary. The water got shallower very quickly, and Beasley was able to make progress, even in the mud.

We rounded a corner, and could see that the water ended at a sandy beach. At one point, the river had flowed around a mesa, and rejoined the flow a quarter of a mile downstream at Bonita Bend. Time and geology had caused the river to abandon this meander, leaving a rincon in its wake. We pulled the boat until it grounded at the end of the beach. We could see a path leading up through the tamarisks to the right. After starting to unload our gear, it became obvious that we needed to relocate the boat to a little slippery ledge closer to the trail. We floated it free, and lined it over to the ledge. Aside from slipping in the mud a few times, it definitely was easier to unload and stage the gear here.

Beasley enjoys the drowned Farfalle and pesto at Anderson Bottom

Exploring up the little side canyon through the bushes, I found several good campsites. One, under a large cottonwood tree, looked promising. It was a bit of a walk though. There were two in the side canyon, but it looked as if it could get flooded in a big

storm. Neither of us wanted to deal with flooding, so we chose a site a bit higher up. We had to climb a sandy bluff about fifteen feet or so, but the view of the rincon was spectacular. And the site was shielded from the wind by a small stand of tamarisk and cotton-wood. There was space for both of our tents and still leave room for a cooking site.

We hauled the gear up the hill. It took a few trips. I wanted to pull the boat out of the water, in case the river rose overnight. Higher up the bank, there were two solid trees to tie it to. We pulled the three big water tanks out, and flipped the canoe over to get the remaining water out of the bottom. And then it was time to set up camp. The plan was to stay here two nights, with a day to explore up the dry meander and climb up to the Buttes of the Cross.

The food box was full of water, as I discovered when I tried to carry it up to our campsite. I had counted on vacuum sealing to keep the main dinner entries dry. Unfortunately, a couple of them had not been watertight, and my pita bread was now pita dough. I sorted the food into piles: dry on one side, wet on the other. When I finished that task, the damage was not too severe. We still had most of our food! The farfalle with pesto had

not fared well, however. The pasta had gotten waterlogged, and had rehydrated. So our dinner choice was pre-determined. I figured cooking it would be fine, so into the pot the noodles went. The tomato sauce was fine in its individual packet, as were the pine nuts. The pesto was in a sealed jar, so it, too, was fine.

Lesson Two: Everything goes in a dry bag. Everything.

Once again, we found the portions too much to eat. After stuffing ourselves as much as possible, and eating some Trail Angel Cake, the leftovers went into the garbage bag. I found a big spare dry bag at the bottom of my pack. Drying each packet individually, the dinner entries went into this big dry bag, and then back into the box.

We sat around after dinner, assessing the damage two capsizes had caused. Both our little point and shoot cameras were destroyed. My Lumix had been in my PFD pocket, and was full of sand and water. Jim's point and shoot was also kaput. But

The remains of my Kelsey River Guide

miraculously, both iPhones survived. Mine had a Mophie battery that somewhat protected it, but the Mophie was a dead soldier. Our GPS satcom devices both worked as well. Evidently iPhones and Garmins are waterproof to about ten feet. Jim had lost a couple of water bottles that hadn't been tied to the boat. And the

Kelsey book was almost completely waterlogged, as my map case had not stayed sealed. (SealLine map case: don't bother). I pulled individual pages apart, and laid them on any available flat surface to dry. In the desert air, it didn't take long. The rest of the book was pretty much a goner. The Trails Illustrated maps were good, as they are waterproof. Belknaps, check. But all the paper info was toasted as well. The key information from Tex's regarding camping spots and mile markers was also soggy. But Beasley had dry copies squirreled away in one of his four bags, so that was good.

It had been an exhausting day. What should have been an easy ten miles had turned into a harrowing, life-changing experience. We were both thankful that we had been able to rescue ourselves, our gear and the canoe. As dusk fell over our camp, I silently thanked God for his mercy, and prayed for safe travels til journey's end. Sleep didn't come easy for me that night. I knew that neither one of us was prepared for the river to be so swift, and so high. Even though I had warned Beasley that conditions might be less than ideal this early in the season, he had no other time window available. Now we were safe on land, but we would have to deal with the river again soon. We still had thirty river miles or so to go to reach Spanish Bottom.

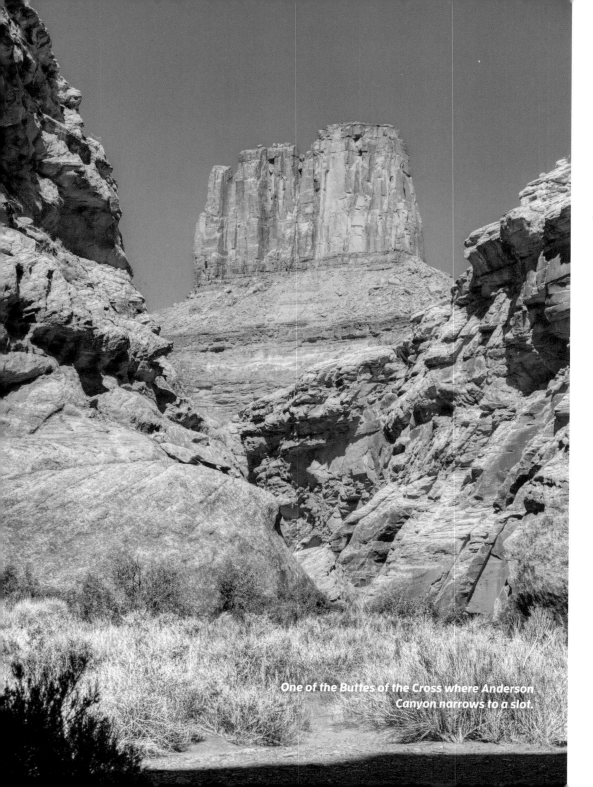

One of the Buttes of the Cross where Anderson Canyon narrows to a slot.

James W. Parker

DAY THREE — FRIDAY, MAY 17

MILLARD BENCHES

Morning breakfast was a simple affair. Happy to have brought the fancy air mattress, I'd slept well enough, once reaching drowsiness. The sun was just beginning to show over the buttes to the east. Crawling out of my cozy cocoon, I forced myself to greet the day with a hot cup of coffee and some instant grits with bacon bits. Soon, I was joined by Beasley. We slowly woke, sipping our hot liquids, planning the day.

According to Kelsey's guidebook, the bottom we were camped on had been used to graze cattle 100 years ago. There was a steep trail leading down into Anderson Bottom from the Millard Benches above it. After breakfast, we washed up our dishes, filled our Camelbaks, assembled camera kits, and set off towards the cliffs. The walking was easy, but many use trails scattered among the cryptobiotic soil of the bottom made it hard to keep on a defined path. Jim elected to walk up the wash bottom, while I found a worn trail leading in the right direction.

As the canyon narrowed, there were some cowboy brands etched into the red rock canyon wall. The sun was high now, and I could imagine cows making their way across the field, browsing and chewing the sparse grass.

Anderson Bottom is the only spot south of Millard Canyon where it is possible to get livestock down through the White Rim to the river in order to water them. Over the years, it had been home to a number of ranchers, starting with Albert Isaac Anderson in 1909. Karl Tangren was the last to settle there, and there is no longer any sign of habitation, although his spring and a cave blasted out of the rock by the Forest Service still remain. I speculated that there had been more forage during the time that Karl Tangren was running his cattle down here.

We wandered back into the canyon until it narrowed down into a tiny slot. There was a muddy pool about 10 lower than the surface of the wash. This slot passes all the way to the top of the bench, but has a couple of drop-offs which make it tough to climb up it. People have managed to canyoneer their way down it, but it didn't look particularly hospitable. Jim wondered how much water had to flow down it in order for the pool to reach the level of the dry wash we were walking in. I didn't want to find out!

Backtracking, we found the iron gate that Karl Tangren had built, blocking the path upward for cows and other livestock. From here, the trail leads up a series of rocky switchbacks, and along a ledge before coming out into another minor slickrock wash. We followed that wash uphill onto the White Rim, and at the top were rewarded

Karl Tangren's gate is visible just above Jim Beasley's head.

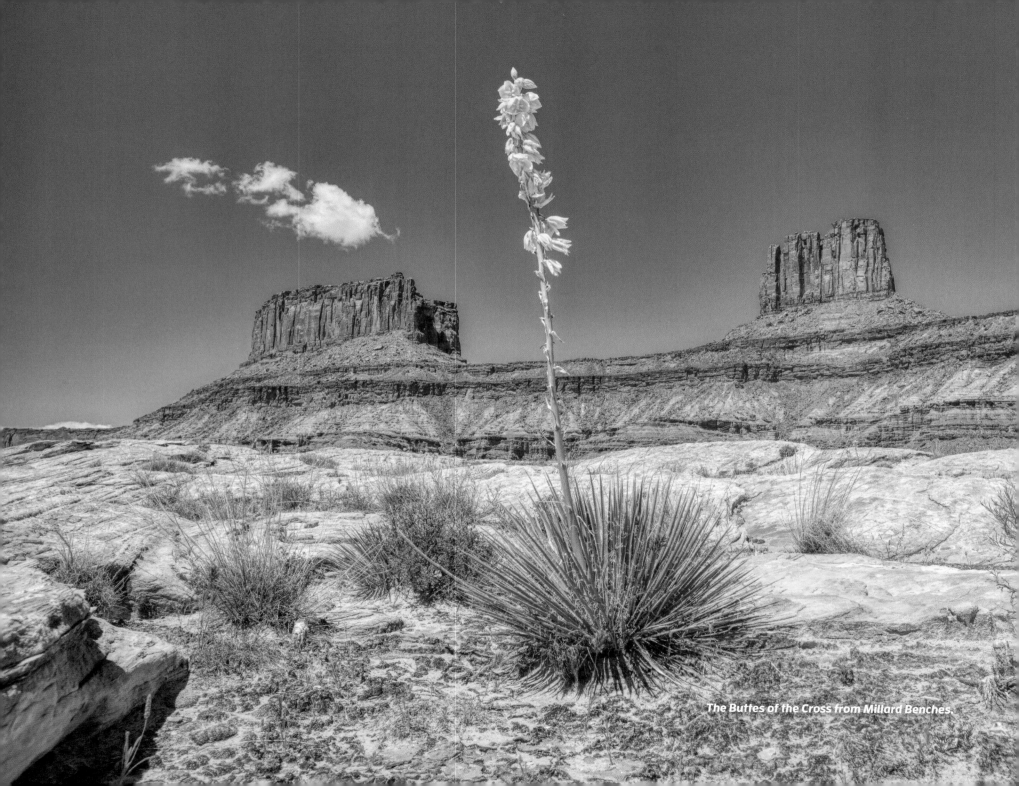

The Buttes of the Cross from Millard Benches.

with a magnificent view of the Buttes of the Cross. From this vantage point, you could see Ekker Butte, Grand View Point and Junction Butte to the South, and the Green River to the East. Jim took his camera and wandered off in search of interesting macro subjects. I made a few images of the Buttes, and sat down to enjoy the sunshine and a peanut butter bagel. We spent an hour or so mucking about on top of the benches. Jim's plan had been to scout the location on day one at Anderson Bottom, and then hike back up in the evening before sunset to camp out, putting us in position to make some images of the Buttes in moon-light. But after seeing them up close, and experiencing the hike up, his need for this particular photographic journey lessened. Coming down the trail again, we agreed that hiking back up in the evening probably wouldn't produce a photograph worthy of the effort.

Walking back to camp, I detoured along the canyon wall towards the old Tangren spring. Jim headed back to camp. I didn't find the spring, but I did find several cottonwood trees offering good shade and tent sites. The sites are a long way from the river, though. I also saw two huge alcoves, and found the cave that the Forest Service had blasted out of the sandstone. In years past, people from Moab and Green River got together for a Friendship Cruise. Boats were put-in at Green River on Memorial Day, and a big dance was held on Anderson Bottom the following evening. A concrete dance floor had been poured and a big tent erected down towards Bonita Bend. As many as 600 people joined the

cruise in its heyday. This Forest Service cave had been used to store equipment and porta-potties for the cruise, until the advent of smaller "groovers". The door was no longer locked, and there was nothing stored there. Now just an empty shell, it serves as a reminder of the good times of years past.

After I got back to camp, Jim hiked over to the other camp up-

Cave blasted into the sandstone for storage of gear for the Friendship Cruise stands empty now.

stream to inquire about landing spots for the remainder of our trip. He took his camera, and I puttered about camp. I reassem-bled what I could of the Kelsey book and my trip info; charged up my GPS with a small Mophie battery; and did other camp chores. When Jim got back, we rigged the tarp he had brought over the cooking area. It had two aluminum poles, some light line, and

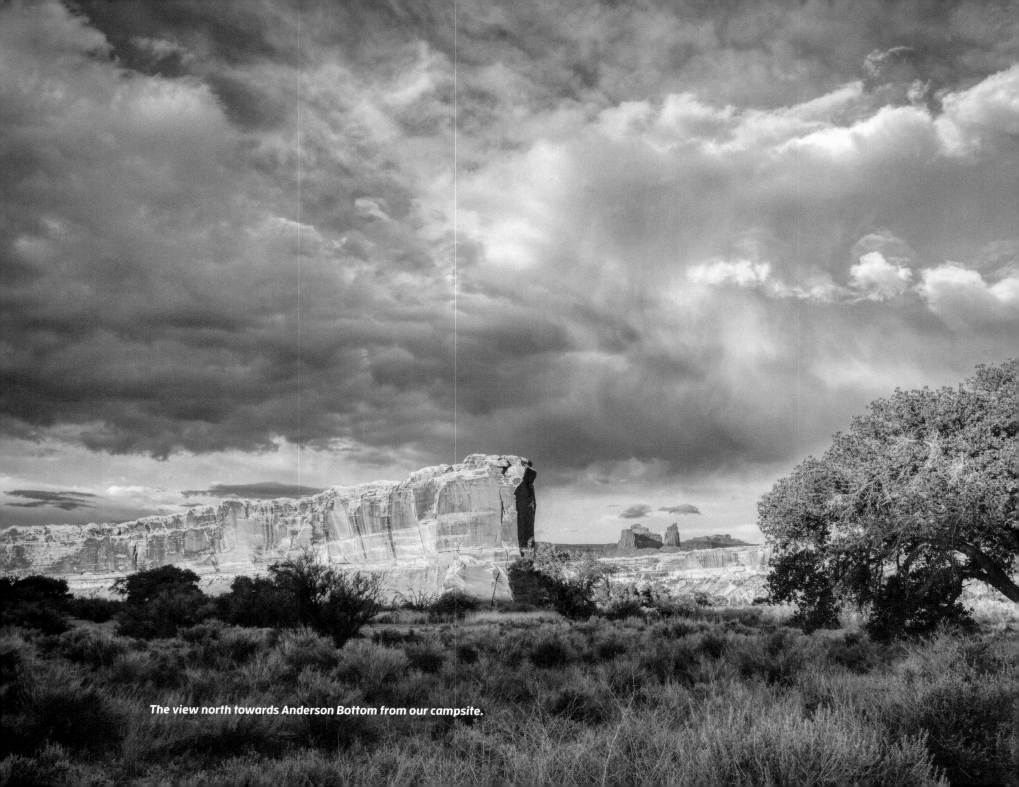

The view north towards Anderson Bottom from our campsite.

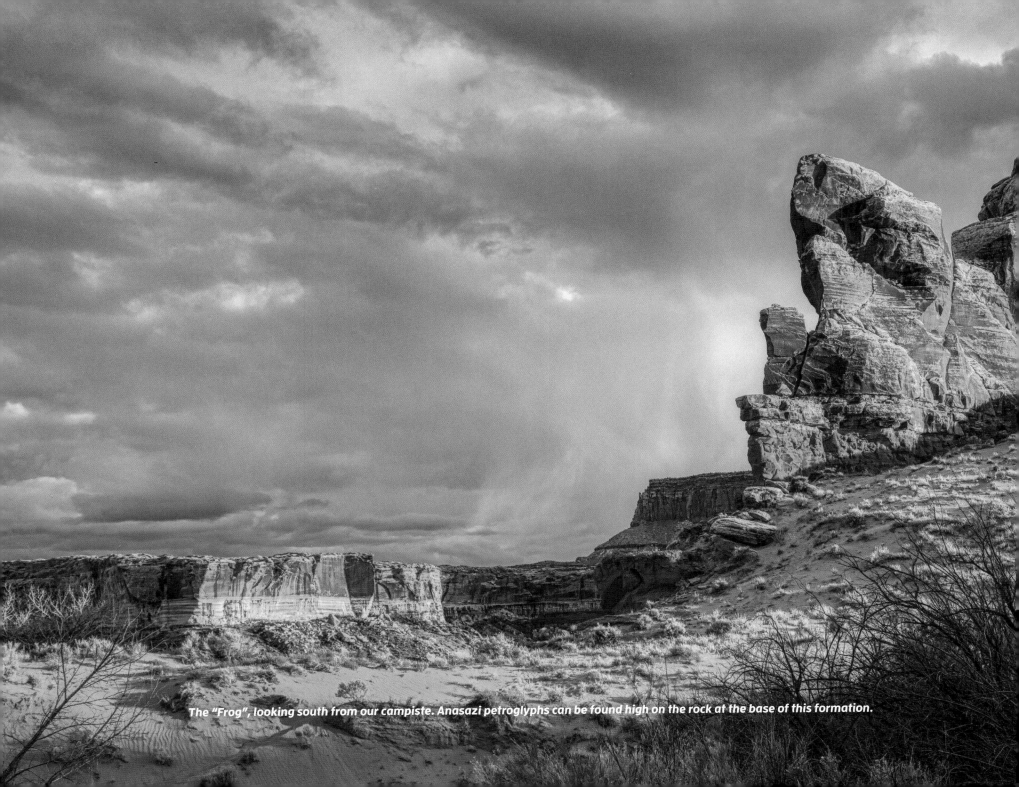

The "Frog", looking south from our campiste. Anasazi petroglyphs can be found high on the rock at the base of this formation.

plastic stakes, which were hard to get to hold in the sandy soil. We used the bushes behind us, and created a couple of sand deadfalls, and managed to get the tarp fairly stable.

Jim took the collapsible bucket down to the river, and brought it back full of river water. We had found that settling out the silt in a bucket with a tiny amount of alum concentrate gave us clear water that could be filtered with a PUR filter. Letting it sit overnight helped, and gave us about 7 liters of water — more than enough for cooking for the day. Even though we had 20 gallons in the three big plastic tanks, we weren't using them as fast as predicted. Cooler weather, and less consumption meant that we just weren't drinking as much as the recommended 4 liters daily. In retrospect, I should have dumped two of those tanks to lighten the load in the canoe.

Once we finished with that task, I wanted to hike over to **"The Frog"**, the large prominent rock sticking up in the abandoned meander. We had met some boaters earlier who had landed and hiked up looking for some petroglyphs, and so were curious to find them ourselves. Crossing the muddy end of the wash, we noticed that the water level had already dropped several inches from the previous day. Our trail led diagonally up the side of a sandy dune, and then up under the north side of The Frog.

"There they are!" One of us spotted the Ancient Puebloan art, way up high along a crack.

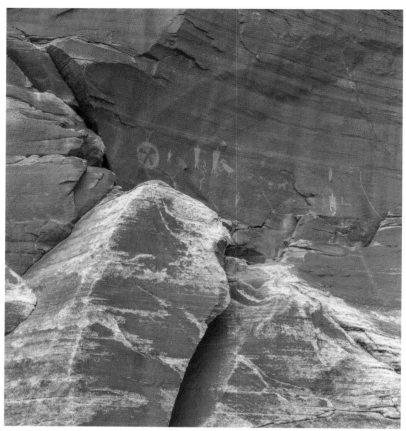

Petroglyphs on "The Frog".

"That must have been some crazy climber to get up there," I commented. Petroglyphs usually occurred at a high traffic point in Anasazi culture, and served as news or a warning to those who followed. Many small granaries and other artifacts dot the cliffs along the Green, and archaeologists speculate that the river made for easier travel than the mesas and canyons that fed it.

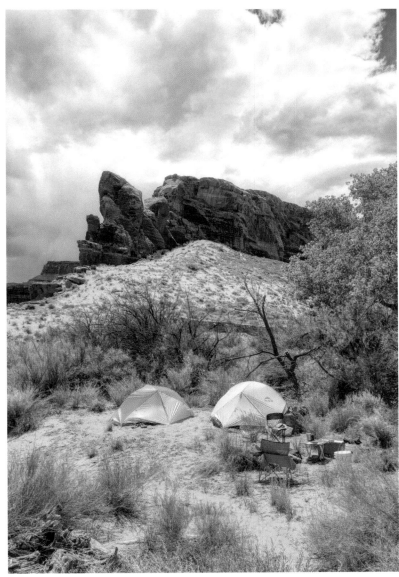

Our campsite at Anderson Bottom.

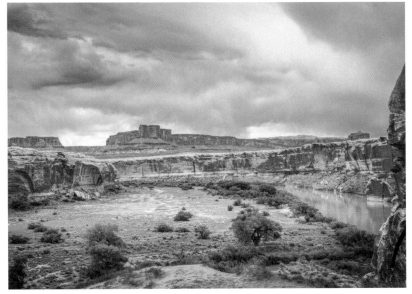

The view upriver from "The Frog".

It is still possible to follow trails along the river, and David Day has a good description of the Lower Trail in his book.

From our vantage point in the shadow of the rincon, we could see the Buttes of the Cross. Clouds were forming overhead again, and we hustled down the trail. Still no rain, though. A small granary was somewhere on the south side, just opposite our position, and for a moment, it seemed feasible to walk around and find it, too. But then fat raindrops started to fall, and we hightailed it down the dune.

Back in camp, our tarp had survived the wind and the rain, but needed to be tightened up again. We were glad to have a bit

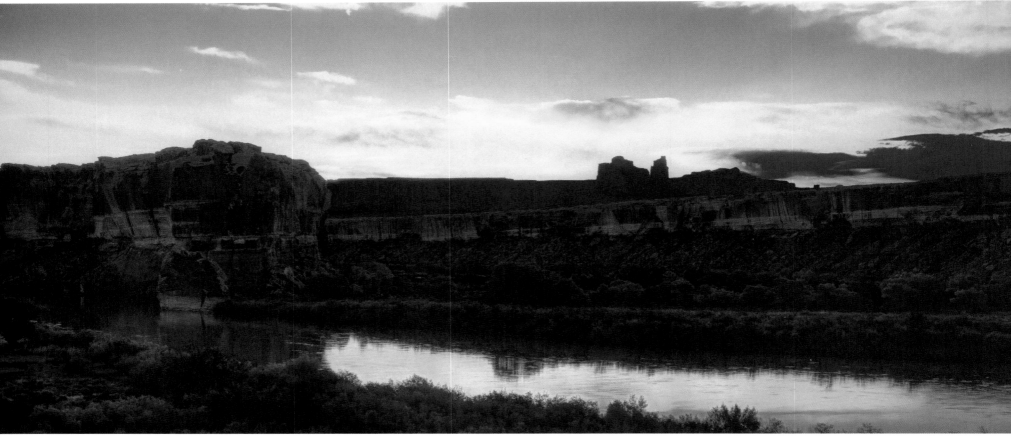

Green River Dawn, Anderson Bottom.

of shelter. I broke out the cooking gear, and whomped up a batch of vegetarian chili. During the prep phase of the trip, I had dehydrated beans and peppers, and found some vegetarian meat substitute. It came together easily on the camp stove, and I think it was the most popular meal we had on the trip. We finished off every last bite, too. And then some sort of dessert, maybe some fruit cocktail in those little snack packs to cool off the chili taste.

ANDERSON BOTTOM TO TURKS HEAD

I woke up before sunrise the following morning. Slipping out of my tent, the air was crisp and clear. Jim was still counting sheep in the tent next door. I put on my puffy and rain shell, and

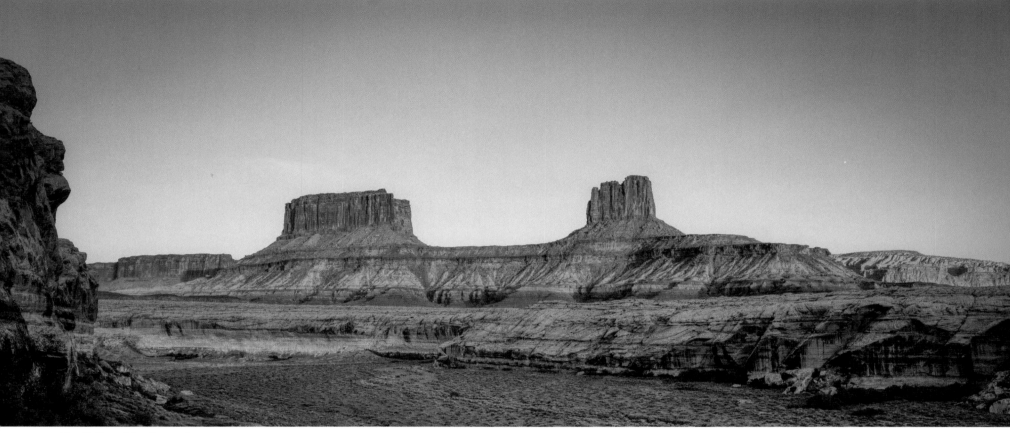

The Buttes of the Cross, dawn.

grabbed my camera to head back up the Frog. Hoping to see if sunrise would reveal a nice image of the Buttes of the Cross, I hustled.

Crossing the muddy flat between our camp and the sandy incline, it looked as if dawn would be cloud-free. It's always nicer to have some clouds to lend atmosphere to a photograph, but today I would take whatever nature threw at me. Finding a

possible angle, I made some test shots. The light was starting to hit the Buttes on the horizon, and the full moon was setting. Not quite the right time of year to get Buttes and moon in the same exposure, but close enough.

I changed position, and moved up the hill a bit to get the shady side of the Frog into the picture. Below me, the grassy plain and Anderson Creek was still in the shade. Looking for a foreground

element, I shifted around a bit. It was getting brighter by the minute. Pausing to watch the sun light up the mesa, it was a beautiful morning. I sensed that everything would be okay. More waiting. A few more exposures. The shadow of a large mesa across the river split Anderson Bottom. The Buttes were in full sun now. I wasn't quite satisfied with my location, but the experience was worth the early morning rise, and the climb to the base of the rincon.

Breakfast over with, we broke camp, and ferried our gear back down through the gully to the canoe. The bank was a bit less muddy, and we floated the canoe in the shallows. Loading it was getting easier, as we had developed a system. Tanks forward, duffels behind the center thwart, food barrels and MSR Dromedary bags in the back. Camera bags went under our seats, and small river bags got tied into a thwart. Both of us shared some silent trepidation about getting on the water again. Swallowing our fear, we got into the canoe and gently shoved off into the water.

The river was still running high. It was early, so the wind hadn't yet begun to swirl up the canyon. But little whirlpools formed at random in the middle of the river. Every time one formed, it did so with a disconcerting sucking sound. There was no predicting where they'd appear. They didn't pose any major threat, and paddling straight through them didn't rock the boat. But they were a bit frightening. Back in camp, we'd mapped out a plan

for the rest of the trip. I had plugged the mile waypoints into my iPhone GPS app, GAIA, and every so often would look at the map. Being on the river was way different than looking at the map, and what appeared to be a big opening in the bank often proved to be overgrown with willow and tamarisk.

The miles went by quickly. Although we didn't have any easy way to measure the river's flow, I estimated that it was traveling somewhere around 13,000 - 14,000 CFM. The record for the Green is up near 20K. We tried to stay near the shore, but not so close that we'd get mired in a shallow, or snagged by trees. There was the occasional flotsam and jetsam floating downriver; bits of trees, and the random water bottle. Jim remarked that he now understood how bottles got abandoned in the river, after our own experiences.

The scenery was magnificent. Towers, buttes, mesas all paraded by as if we were on a conveyor belt. Although geologic landmarks and cliff dwellings were marked on Belknap's map, we weren't able to identify much. We passed the Sphinx without really commenting. When we'd pass a possible landing spot, our necks would crane, and we'd mentally solve the problem of getting to it. We saw a couple other parties on shore near Holeman Canyon or Valentine Bottom. It was impossible to really tell where we were, given our inexperience with the river. But we enjoyed the drift, barely paddling enough to keep the bow pointed downstream.

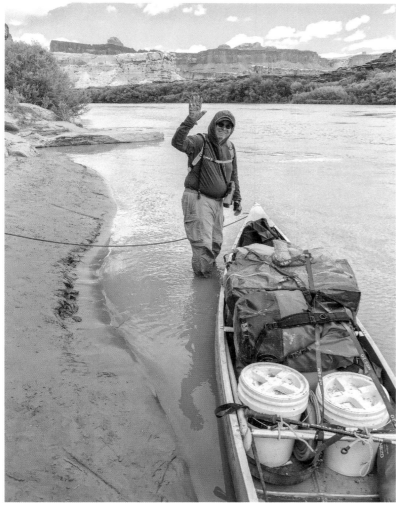

Nailed the landing at Turks Head!

kept on the lookout for the landing ledges. Luckily, this one was easy to spot on the far side of the meander. Several large rocks flanked a wide ledge, and we were able to come around and get the boat nudged into the sandy bottom. This time, the river was solid underfoot, and there was a big tree growing out of the sandstone to anchor too. We tied the boat up. Both of us clambered up the bank, Jim going one way, and I the other, to check for available camp sites.

Going to the left, I found three marvelous sites nestled below 50' cliffs, commanding a 180 degree view of the river. "This will do!" I cried out to Beasley.

We ferried our gear up to the camp. There wasn't another soul in sight. It was still early in the afternoon. We'd only had to cover 10 river miles, and with the fast flow, it had taken us at most 2.5 hours. There was a nice alcove, partially sheltered, with two big flat stones that we could use for a kitchen. Jim and I both pitched our tents, after checking to see that tent pegs would actually go into the sandy, rocky ground. The business of creating a temporary home finished, we sat for a moment.

Hearing the sound of voices, and the clanking of canoes hitting rock, we looked over the edge, and saw two boats pulling in to the ledge. One was a Tex's Riverways catamaran canoe — a device to tie two canoes together and provide more load space for the occupants. We had considered that option, but it seemed awfully ungainly to maneuver. The three women came up the

The big outcropping known as Turks Head came into view as we passed Tuxedo Bottom on the left. A massive formation formed by a river meander, Turks Head towers over the landscape. We

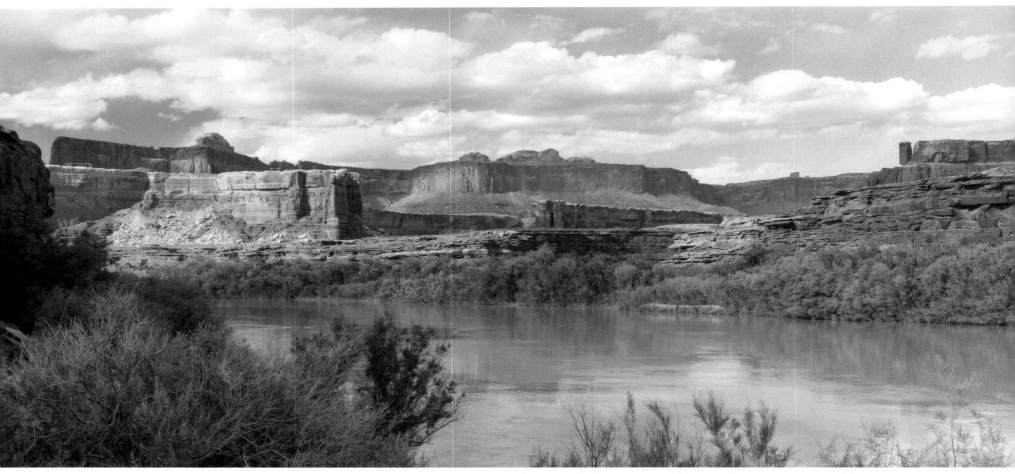

The Green River at Turks Head, our third put-in. Soda Springs Canyon, one of many small tributaries, is visible across the river in the center of the photograph.

trail, and we spoke briefly. They weren't looking to camp, but just to explore. There were reputedly many ruins around Turks Head, and it is known for its flint knapping remains. They walked off downriver, and then twenty minutes later, came back the other way. We heard their voices up on the ledges overhead. When they came back an hour later, we didn't hear if they actually found the ruins, or just wandered about under Turks Head.

With camp established, we pulled some camera gear together and went off to find some ruins ourselves. There was a use path heading north around the meander, and we followed that for a good mile or so. It stayed close to the cliff, and got rocky and slippery in some spots. There were places that might have had ruins, but didn't. After walking, scrambling and clawing our way around it, we decided that we weren't going to find much on

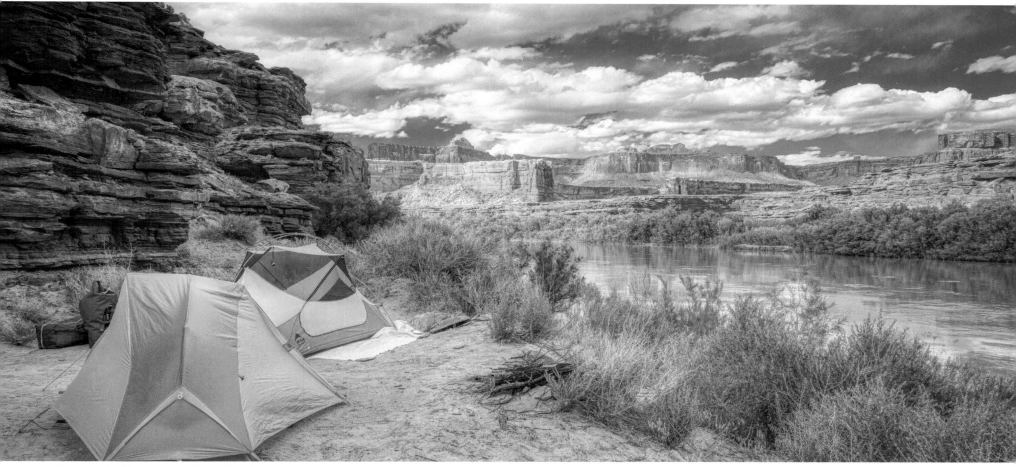

Campsite looking upriver at Turks Head.

this route, and turned back. Near camp, a path zigzagged up a gully. Beasley decided to wander around on the plateau, and I went back to camp to do something unmemorable. A couple of times I heard him above me, and he stuck his head over the side and took a picture of me. He was gone for a while, and when he came back, he had still not located any ruins. But he had found a good way to access the plateau below Turks Head.

Time for another famous Parko dinner. I don't recall what we ate, but I did learn that about half what I had allotted was the right amount. That left room for dessert, which may have been lemon pudding cake, or possibly the trail angel food cake with chocolate sauce and dehydrated strawberries. Either way, it was a treat to be able to spare the extra weight to bring some sweets along. I also had a pint of Tin Cup American Whiskey, and I enjoyed a wee

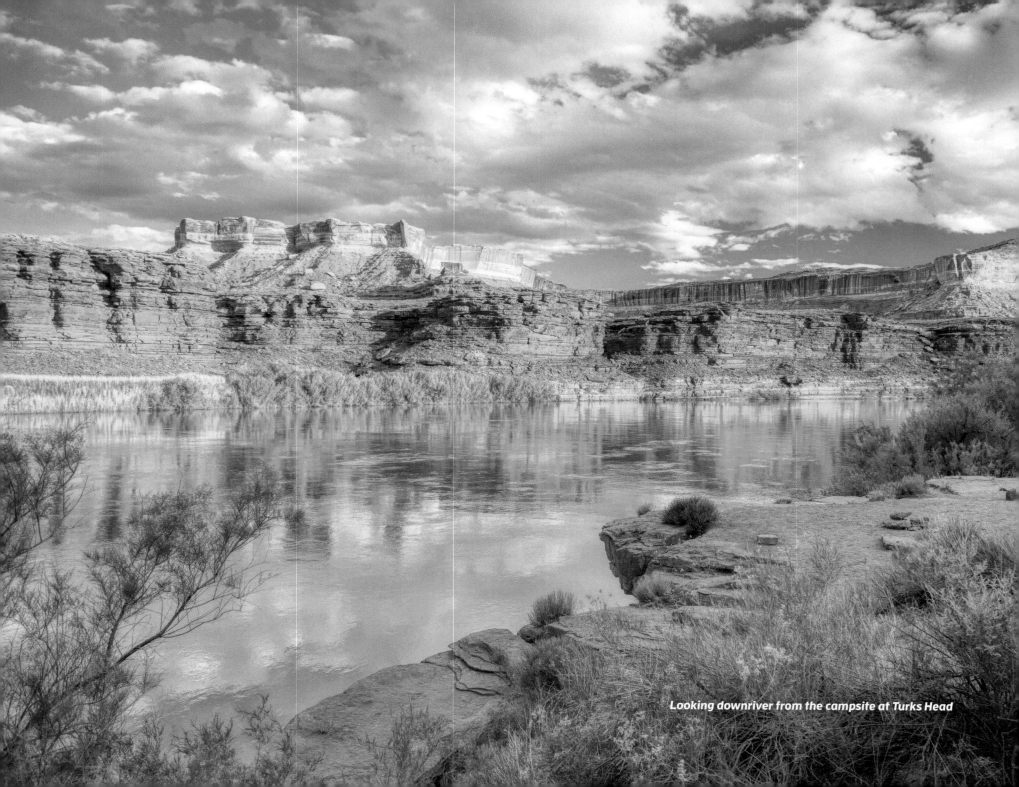

Looking downriver from the campsite at Turks Head

dram of that after dinner was done.

As gorgeous as the view from our overlook was, it also left our tents a bit exposed. This site commanded a view of the river both upstream and downstream, and the sunset was beautiful. Overnight, the wind came up. We could see the full moon popping in and out of the clouds. Bringing tripods to do some astrophotography had seemed like a good idea, but the weather hadn't really cooperated so far. I pulled my tripod out and made a few shots of the moon setting over the cliffs downstream, but that was the only time I actually used the tripod. Were the pictures any good? No.

I left the flap open on my tent when I turned in, so that I could watch the moon drifting over the river. It was a peaceful way to fall asleep.

DAY FIVE - SUNDAY, MAY 19
TURKS HEAD LAYOVER

Dawn brought with it clouds and an overcast morning. The usual camp chores occupied us. Filtering the silt from water left settling overnight. Refilling drinking water from the heavy jugs on the landing. Making coffee, making plans. After we ate, I spent some time looking at the maps, and plugging location data into GAIA. Beasley decided to climb the trail and go looking for the ruins on the mesa above, so he took his camera, and set off.

We had the whole day ahead of us, and no ground to cover, so I wasn't in that much of a hurry.

The light was gray and soft. The river looked as if there had been a storm somewhere upstream. Big logs, and small branches floated with the current. The constant sucking sound of whirlpools forming and disappearing in the water blended into the background. I concentrated on my immediate task. Our next stop, Seven Mile, had a trail leading up to a double alcove, and somewhere along the rim there were some old iron bedsprings that we wanted to locate. Finding it on the maps was an inexact science.

After an hour or so, I took my camera, donned my rain jacket, stuffed a couple of granola bars in my pocket, and went off to find Beasley. A series of rocky steps and gullies led back and forth, until leveling out on top of Turks Head bench. No sign of Beasley, though. It was chilly above the river, and I zipped up my jacket. There were bits of chert in piles everywhere. Turks Head is known to

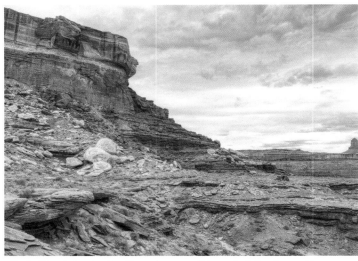

Turks Head dominates the oxbow on this part of the Green River

Bottomland near the river below Turks Head

be an ancient Puebloan flint chipping site, and the evidence was overwhelming. Stopping to inspect a promising fragment now and then, I never did turn up an arrowhead or tool of any kind. Working my way around to the north, I kept an eye out for Jim. Below me, a wide bottom looked as if it would have made good farmland for the Indians. No sign of the ruins, however. Neither of us had a good idea where to look, and Kelsey made it seem as if they were obvious. In retrospect, they probably were, if we had just walked a little further to the northwest.

Turks Head loomed overhead, and finally I spotted Jim high in a gully, silhouetted against the sky. I shouted to him, but my words were cast away by the wind. Hustling up the boulders, I finally caught up to him. Together, we descended the rocks, and marvelled at some of the larger boulders that had broken loose from the main formation. Several of them looked as if they'd made good shelter for a flint camp at one time, with pools of stone chips nearby. Jim said he'd not been able to find the ruins, either, and we gave up on that idea, as it was getting chillier.

On the way back, I detoured down a couple of washes to look under promising alcoves, but no luck. An endless labyrinth of gullies, washes, cliffs and ledges surrounded Turks Head, and must have made it feel like a safe place for the Ancient Puebloans. With views of the river and Soda Canyon, enemies could be spotted miles away. We retraced our steps back to camp, where I heated up some dehydrated vegetables to make soup. That turned out to be fairly tasteless, and

augmenting it with a bit of jerky and a granola bar helped some.

A spot of rain forced us to move the kitchen gear up closer to the overhang. While you couldn't call it an alcove, it did keep most of the equipment dry enough. In doing so, I discovered a little grass and rock structure that a previous camper had left behind on a tiny ledge. In this location, it seemed like an offering of sorts. The rain stopped again, and we hung out, just watching the river.

Closer to dinner time, we saw two canoes struggling against the wind, making their way slowly downstream. One craft was manned by a single person facing backwards, just keeping a paddle in the water to control the boat. The other two people were working their way slowly down the river, not paddling, but just steering the canoe. We thought perhaps they would land here, but they were on the opposite side of the river. Looked like they may have been heading towards Dead Horse Canyon.

I cooked up some dinner, and we battened down the hatches. The canoe was tied to a tree in the river, but floating in the eddy next to the rocks. Earlier, I had used our spare life jacket to pad the side of the canoe against the incessant lapping of the waves banging against the boat. It looked as if we might have some stormy weather later in the evening. Clouds obscured the moon, and we made sure that our gear was under cover. Soon, the still air was punctuated by the sound of snoring.

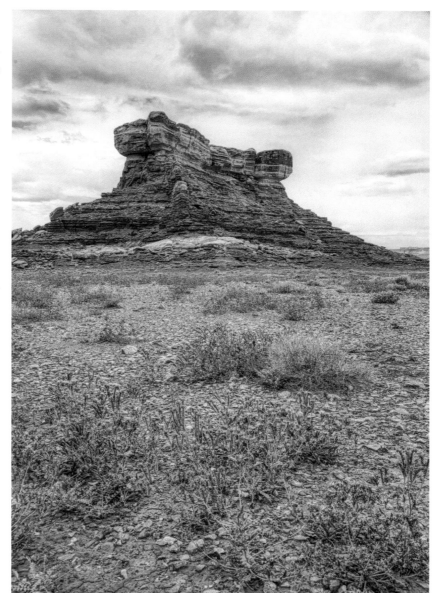

Turks Head

DAY SIX - MONDAY, MAY 21

TURKS HEAD TO SPANISH BOTTOM

Day Six was chilly and overcast in the morning when I woke up. It appeared as if there'd been a storm further north, as the river was swollen and running fast. Whirlpools kept boiling up and disappearing. The water level was up, and almost covered the flat rock at the landing where we had originally taken out. Jim and I set about making breakfast and breaking down the camp. Our plan was to boat downriver about 14 miles to Stovepipe Canyon at RM7. From the reading I did, 7 had an exposed campsite. The draw was the trail that headed up Stovepipe Canyon to the double alcove and an abandoned cowboy camp. Our intention was to camp there, and possibly hike up to the alcove with minimal gear to spend the night. That would leave us two days to paddle the remaining 10 miles to Spanish Bottom, and give us time to hike at Spanish Bottom.

Loading the canoe was fairly easy once all the gear was moved to the landing. We were well practiced, and knew where everything should be stowed. Bungies and lashing straps in place, we pushed off from shore. The paddling was easy, since the river was doing most of the work. It took a few minutes for us to get balanced. The boat was still tippy from the weight of the water and the gear. We still had two of the three big jugs of water on board, each weighing about fifty pounds, plus smaller bags and tanks.

Neither of us did much talking. As we passed the mouth of Dead Horse Canyon, we saw a number of canoes and a couple of paddlers. The pair of boats we'd seen the night before had found safe harbor. The scenery unfolded. There were fewer bottoms in this stretch, and the canyon walls seemed to be closing in. As before, stiffness began creep-

ing into our bones from sitting in one position. Keeping our eyes open for a potential landing, both of us needed a break. Thinking we might be able to stop at Murphy Canyon, at RM 15.3, we must have blown right by it. The tamarisks obscured everything, and made me leery of tiny tributary openings. With our experience at Anderson Bottom looming large in my mind, I was skeptical of every apparent opening.

We kept close enough to the bank to turn in and land. I don't recall if the wind was as much of a factor as it had been on previous river days. But it was chilly, and the river gave me a sense of foreboding. The gray skies didn't help my attitude. I kept an oar in the water, making little course corrections, and trying to spot landmarks. At one section, there were some flat rocks along the right side of the river. We put the boat close to shore, but the water dropped off steeply, making it difficult to get out of the boat. It didn't help that there wasn't much to tie the painter too, either. We pushed off again, and kept on moving downriver.

At Jasper Canyon, a sharp turn led to a landing, but it was occupied by several other canoes. It didn't look as if there was any space for us. I was squirming in the stern, and Beasley definitely looked uncomfortable. We were moving fast in a shore eddy, and just ahead we could see a large collection of trees and branches caught on a sandbar. The current pushed us quickly through the narrow right-hand channel. Only hard paddling kept us from being pinned against this obstruction. We missed it by a foot or

two, and my adrenaline was pumping.

Past the brush pile, the river calmed a bit. We took a breath. Only a couple of miles longer to Stovepipe Canyon at RM 7. We thought we could hold out for a potty stop until then. By this point, I was mainly concerned with getting down the river without getting wet or losing any gear. Beasley issued an occasional word to steer left or right as I would look for the main channel. The canoe required constant attention to keep it pointed downstream, and it was very difficult to sneak a look at the GPS to get a location fix.

Finally, we neared the spot where we thought we would land. A steep bank led up to a flat area where tents could be pitched. There was no shade here. The left-side landing had tamarisks extending out into the water on the upstream side, and the current was swift. We attempted to turn upstream, but the eddy near the shore caught the boat, and we were downstream too fast, carried backwards by the current. There was no way we were going to be able to fight the river and get to the bank before getting caught by the trees on the downriver side of the landing. We aborted the landing while we still had the chance.

Disappointment flooded both of our minds. We'd been unable to find a landing in over 14 miles. At least a landing we could stick. Our confidence was low. I know Jim had his heart set on hiking to that alcove, and discovering the cowboy bedsteads. I was disheartened, too. We floated in stony silence for a few moments. Then I spoke my mind. "My main goal is to get down this river in one piece," I said.

Jim reluctantly agreed. I knew that there were two other possible camping spots at Shot Canyon and Powell Canyon, but at this point, I was not all confident that we could get the canoe safely to shore. "We might as well go all the way to Spanish Bottom," Beasley said.

We passed Shot and Water Canyons. Again, it looked near to impossible for two newbies to land safely. The tributaries were narrow, the bushes reaching out as if to grab the hapless boater. At this point, Stillwater Canyon got much narrower, with rock walls reaching high above our heads. I was past the point of admiring the scenery at this point. We had learned to work together, paddling in unison, and this, at least, was some small comfort. I kept a watchful eye on the current, looking downriver for potential obstacles and swift eddies. Mostly the river flowed straight and fast. We'd lost the mud-sucking whirlpools for the most part, which psychologically were unpleasant, but physically harmless. The red rock above us was gray in the gloom of the day, and there was too much current to provide good reflections. Neither of us had taken any pictures on the river since losing our point-and-shoot cameras at Anderson Bottom.

As the walls closed in, the river got faster. At Powell Canyon, the wind came up and we could see big storm clouds to the east, over the Colorado River. We neared the Confluence, and the water from the Colorado started creating standing waves upstream into the Green River. We kept paddling forward, strong, sure strokes against the waves. The canoe bucked up and down with each

wave, but kept its course true. And then we met the Colorado.

No time to take pictures at the Confluence. At this point, landing the craft was our top priority. The moment passed without being memorialized. The Colorado seemed swifter than the Green. There were a couple of small sandy beaches on the east side, but our goal was Spanish Bottom. Passing a lone kayaker, we waved, as he appeared to be putting on some additional dry gear.

The river register sign went by on the left at RM 215. We did not stop to register. There were some small riffles here, and we wanted to be able to land on the opposite shore at the first opportunity. A couple of large boulders popped up, which we steered around. Just past the second boulder, a riffle crossed the current. With no time to go around, we went through, and scraped the bottom of the canoe on a rock. Lucky for us, the water was fast enough, and deep enough to float us over.

I spotted some sand on our right. "Turn!"

We turned, Jim crying out to me, "What are you doing?"

"Landing the boat!"

I steered us straight towards a small patch with a path leading onto the shore. The bow caught sand, and we were safe. We tied the bow painter to a clump of willows and got out of the boat, our knees shaking.

"This was supposed to be a flatwater trip!" Beasley said.

"Flat, but fast." I replied. I could see that he was even more scared than I had been, and waves of relief flooded through me. We were both overjoyed to be safe on dry land. The Green River had given us much more of an adventure than either one of us had bargained for.

There wasn't a soul camped at this spot in Spanish Bottom. Once we walked up the bank, there were several good tent pads, and some trees and boulders for protection against wind and rain. It was a perfect camp. We unloaded the canoe for the last time, leaving the heavy water tanks on shore. Once the canoe was empty, we set up our tents, found a good location for the kitchen next to one of the boulders, and hid the groover behind a tree. We sat for a while and listened to the river run. After a while, a nap seemed appropriate. Neither of us had much energy for photography or exploration.

An hour or so passed. I woke up, feeling refreshed, and went down to make sure the boat was secured, and pulled it up higher onto the shore. Tomorrow morning I would wait for the jet boat to come down river to see if they could extract us a couple of days earlier than planned. According to Tex's website, they normally couldn't take more on the shuttle than originally reserved, but I figured there was a possibility. Never hurts to ask.

I don't remember what we had to eat that night. There was an overwhelming sense of relief that we had made it downriver safely, with no major incidents. We had a couple of minor scares,

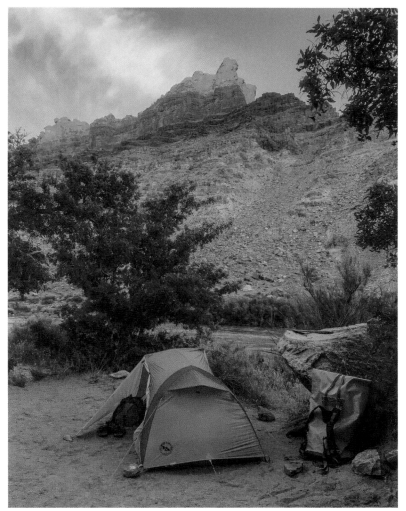

Sunrise kisses the peaks over camp at Spanish Bottom

sure, but nothing involving life, limb or loss of gear. During my nap, I had dreamed about being in the canoe, and the air mattress beneath me had seemed to rock to and fro with the motion

of the water. Jim admitted to the same sensation, akin to sailors coming ashore after a long sea voyage.

It was a beautiful evening. We sat near a large boulder, enjoying the last rays of sunlight bouncing off the high cliff across the river. There was an orange mallow bush blooming under a cottonwood tree near my tent. I promised I'd get a picture of it when the light got better.

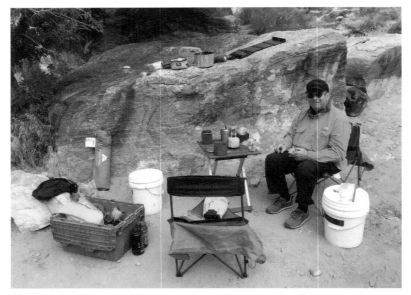

Spanish Bottom camp kitchen, sheltered by a great boulder

We talked about our experience, and what had gone right. We also talked about some of the things we could have improved on the trip. I felt the canoe was seriously overloaded, causing it to be more unstable than necessary. In retrospect, being able to settle

and filter silty river water was something I hadn't been sure about, and I overcompensated by bringing the three heavy water tanks. I should have dumped two of them way back on Anderson Bottom. But ten days was the longest expedition I'd ever planned for, and I wanted to be sure we didn't run out of water in a desert environment.

The Dollhouse, aptly named

Smart, but stupid. Jim had far too much gear with his five duffel bags. I never did find out what was in all of them. Cameras in one, clothes in another, tent and sleeping gear in a third... all of my gear fit into one large dry bag, with the exception of food and stove. There were other learning experiences, too. We talked into the evening, and I felt as if the trip had been a success, even though we'd not gotten up into Stovepipe Canyon as planned.

DAY SEVEN — TUESDAY MAY 21

SPANISH BOTTOM

The next morning looked to be a fine day. I got the camera out and made a couple of shots, made my trip to the river to check on the boat, and had my coffee. Knowing that the shuttle made its way down the Colorado around ten, I waited on the beach when I heard the sound of its engines. You could hear it a mile away, literally. When it came into view, it was a small boat. I waved, and the pilot waved back, but kept moving downriver. About twenty minutes later, the boat came back, and pulled close to the beach. He had a hiker on board that needed to disembark. We talked for a minute, and luckily for us, he had a pickup the next day, and he thought he could get us on board as well. The hiker was due to meet a large party of students from BYU, who would also be traveling upriver on the shuttle the next day. They hadn't arrived at Spanish Bottom yet, and so he was headed off to do some hiking on his own. This jet boat was tiny, though. I couldn't see how he was going to get 20+ people on board, plus 10 canoes and gear. I said to Jim, "I hope he's got a bigger boat!"

Tomorrow's plans in place, we decided to hike up to the Dollhouse. The Dollhouse is a well-known group of spires at the top of Spanish Bottom, only accessible by 4WD road

Walking towards the Dollhouse. Two kinds of prickly pear blossoms.

in the Maze District of Canyonlands, or by hiking up from Spanish Bottom. To get there, we walked south through the grassy bottom. Along the way, we saw two other landing locations on the river. Towards the end of the bottom, the bigger campsite was difficult to reach by canoe, because of the high water. The kayaker we had seen the day before had set up camp there, but wasn't currently in camp. The bank was steep here, and tamaracks popped up in the middle of the flooded landing. Happy we landed in the spot we did, we pressed on.

The trail leads out of Spanish Bottom up a rocky hillside. Steep at times, 1000' of switchbacks need to be conquered before you finally reach the Dollhouse. The views back into the valley are beautiful. We could see the last campsite before Cataract Canyon: Red Lake Canyon. A number of rafts were lined up, ready to run the rapids in Cataract. Our campsite wasn't visible through the scrub trees, but we knew we were at the head of the valley.

The Dollhouse is composed of Cedar Mesa Sandstone, laid down in the Permian Period over 250 million years ago. Spires, hoodoos and cliffs sculpted by wind and water greeted us as we topped the last ridge coming out of Spanish Bottom. The climb was hot, but worth it. At the top of our hike, we had the choice to continue to Surprise Valley and some ancient Puebloan ruins, or walk further up to the very top of the Dollhouse. I sat for a few minutes enjoying the view and some trail mix. Jim wandered up the trail with his camera. After I ate, I made some exposures to

The Dollhouse, framed by a cedar snag.

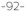

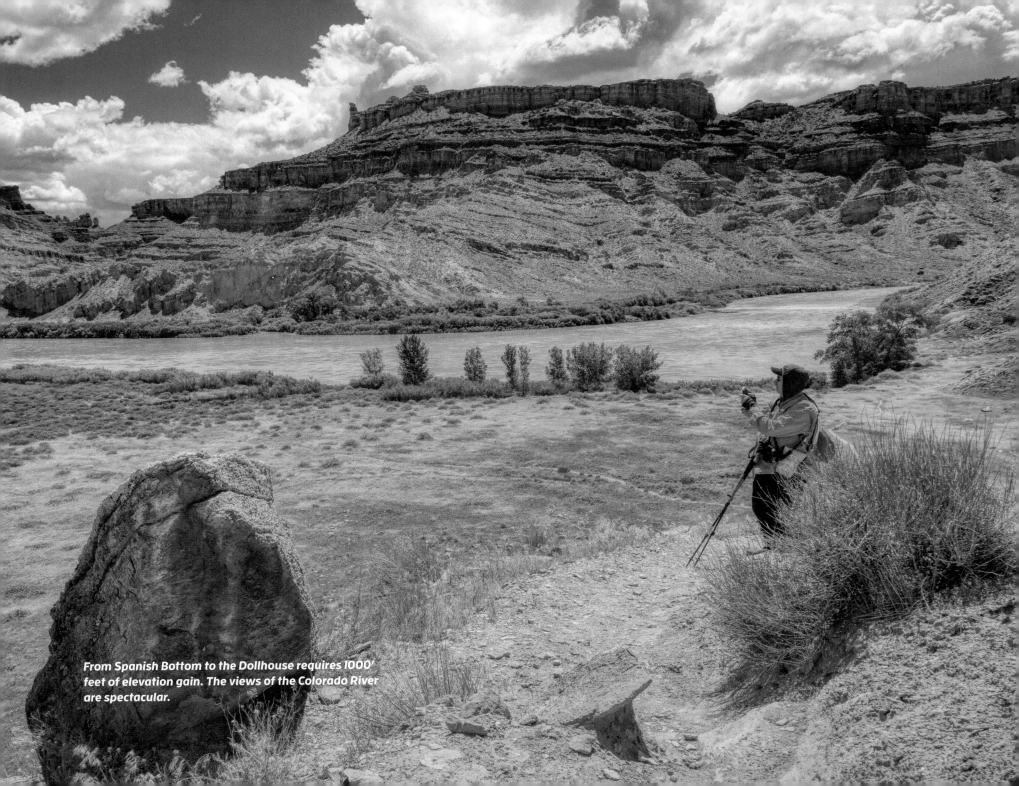

From Spanish Bottom to the Dollhouse requires 1000'
feet of elevation gain. The views of the Colorado River
are spectacular.

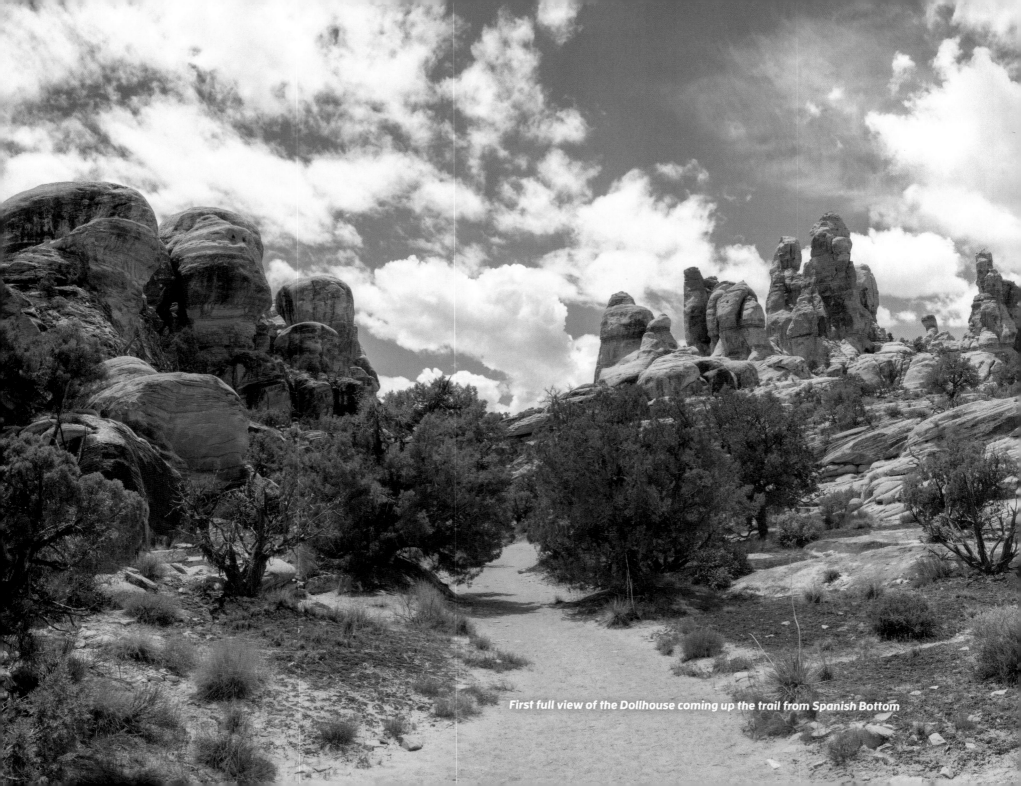

First full view of the Dollhouse coming up the trail from Spanish Bottom

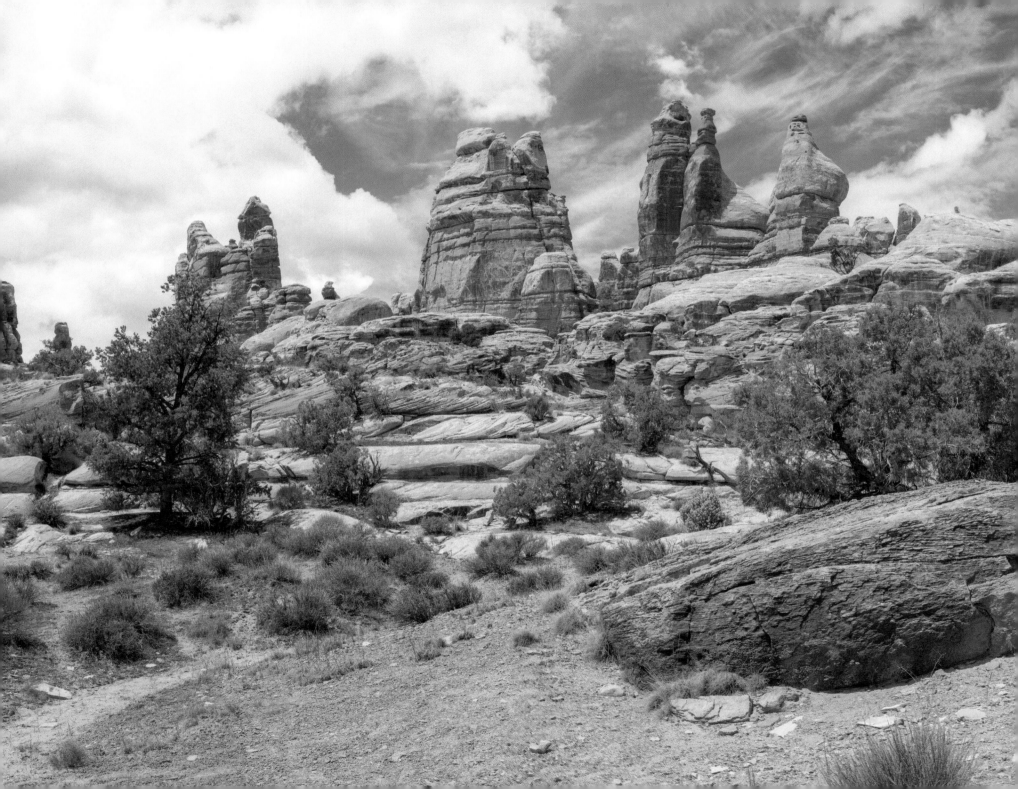

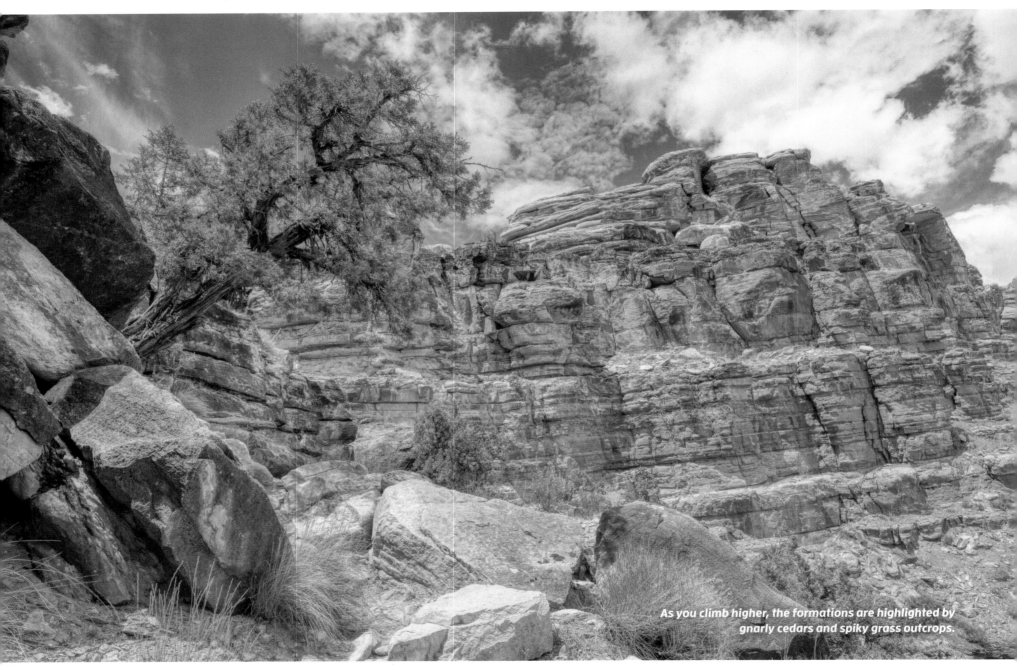

*As you climb higher, the formations are highlighted by
gnarly cedars and spiky grass outcrops.*

stitch together later as a panorama.

Clouds were starting to gather, so we continued up the path to check out the view. Along the way, stunted cedars provided interesting framing opportunities. Many use trails dotted the main drainage, even though cairns marked the way. The Dollhouse is accessible by a very rough 20 mile 4WD road — it can take 5-8 hours to get into the area. There are three campsites, reservable through the National Park Service. At the top, we could see dark storm clouds within striking distance, so we did not linger long.

On the way down, we met the BYU group hiking up. We had seen them coming down the river earlier in the afternoon, landing at lower Spanish Bottom in the willows. It didn't look easy. There were 18 young college students on a study trip, along with several advisors. The group was strung out a quarter mile along the trail, with the stronger hikers in the lead, and the out-of-shape backpackers bringing up the year. Their plan was to camp at the Dollhouse, and then hike down in time to catch the shuttle back the next morning. We wished them luck, and headed back to camp, catching a few raindrops on the way.

Before loading it onto the jet boat, the canoe needed to be cleaned out to remove all the mud and sand. Jim and I decided to move it a few yards downriver, where there was a better landing spot for the jet boat. We took the collapsible bucket, and rinsed the canoe out with river water before turning it upside down and draining it. A couple of cycles, and the canoe was clean as a whistle.

Jim Beasley brought wine in a can and several varieties of liqueur.

Dinner was calling. And cocktails. I still had a good amount of bourbon left, and Jim had several cans of Chardonnay, and some little bottles of liqueur. We decided to celebrate our last evening

and always left the wood behind for the next campers. Tonight I was hoping we could finally have a little fire, but somehow it never got started. Jim and I stayed up late, sharing personal details and experiences. We lit the fire of friendship, but never burned a single twig. We also polished off two cans each of the chardonnay (it wasn't bad, even warm), about six airline bottles of various liqueurs, and most of the bourbon. Needless to say, we slept well that night.

DAY EIGHT — WEDNESDAY, MAY 22

SPANISH BOTTOM TO MOAB

Sunrise woke me early the next day. I made a few pictures of the camp and the Dollhouse on the rim of Spanish Bottom. It looked like a fine day. Jim and I had our morning beverages, and began to break down camp and get ready for the shuttle. It went fairly quickly, even though we didn't expect the jetboat to pick us up until after 10. We got all the gear down to the little beach around 8, and right about that moment, we got hit by a summer shower.

We could see it coming from the south. Dark storm clouds headed our way from the Dollhouse, and more storm clouds to the north east of the Colorado. Huddled on the shore in our rain gear, there wasn't much we could do, except sit on the food barrels and wait it out. I had both a rain jacket and pants, but Jim

Parker enjoying the last dinner in camp. Photo: Jim Beasley

in style. We had carried our required fire pan the entire trip. At each campsite, I had gathered driftwood in anticipation of a cheery blaze, albeit a small one. We'd never used the fire pan,

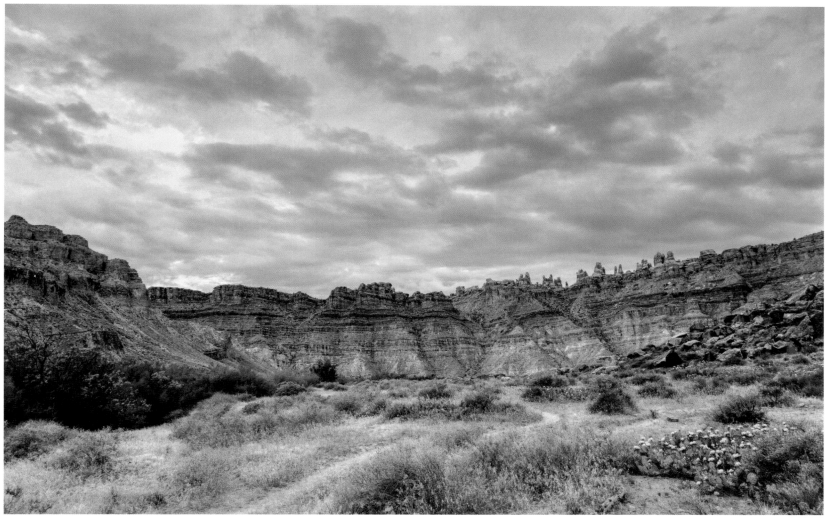

The Dollhouse from Spanish Bottom, before the rain hit us.

only had a rain shell. His legs got pretty soaked, and there wasn't any good shelter since we'd packed the tents. Better to get the gear packed while it was still dry, though. There's nothing worse than having to dry out all your gear in a small hotel room. So there was that.

It was cold on the jet boat. Capable of running almost 30mph, the open craft offers little protection against the elements. With a dozen canoes stacked overhead, the rain still found its way into our faces, and soaked our legs. The man next to me, one of the BYU trip leaders, was still in shorts. I got the full story about their trip and the class curriculum while we weathered the ride upstream. It hailed on us, twice, little bits of icy water sandblasting any exposed skin. We passed several raft groups headed towards Cataract Canyon. Most of them were roped up together, and floating. They looked miserable in the cold, damp weather.

Halfway up the river, Kenny asked if anyone needed a potty stop. There is a full-on pit toilet at Lathrop Canyon, and some rafts were stopped there. No one spoke up, so Lorenzo backed off and continued up river. Then someone changed their mind. Lorenzo brought the boat in close to shore and a couple people hopped off and headed for the bushes.

Back on the river, the BYU group shared their snacks with us. They had chips and cookies and some other tasty stuff. I had my little bag of trail mix, too, so we didn't go hungry. They were a happy crew, singing songs, and generally distracting themselves from the uncomfortable journey. A lightning strike on one of the tall mesas behind us interrupted the singing only momentarily. Towards Potash, the river opens up, and we saw a couple of ranches on the upper banks. We had passed Dead Horse Point

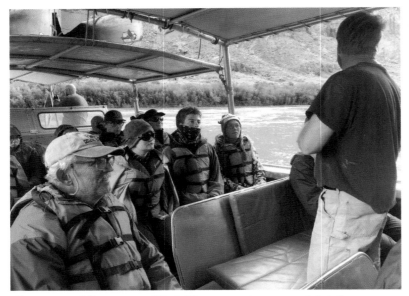

Kenny, one of the owners of Tex's Riverways, gives us a safety talk.

The rain continued for almost an hour. Around 10, we heard the roar of mighty jet engines, and soon the shuttle came tearing down the river. This was a much bigger boat. The two pilots indicated that they'd be back for us after they got the BYU crew. Kenny and Lorenzo were manning the boat — they are the two owners of Tex's. Half an hour later, we were loading gear onto the shuttle, dumping the remaining water out of our big tanks, and hopping on board. Kenny gave his safety speech, along with some do's and don'ts. Beasley and I grabbed the last benches on the boat, the forward seats. We were exposed to the wind and weather as we blasted up the Colorado. Two miles upriver, we saw the Confluence from another angle, and the rain started pouring down again.

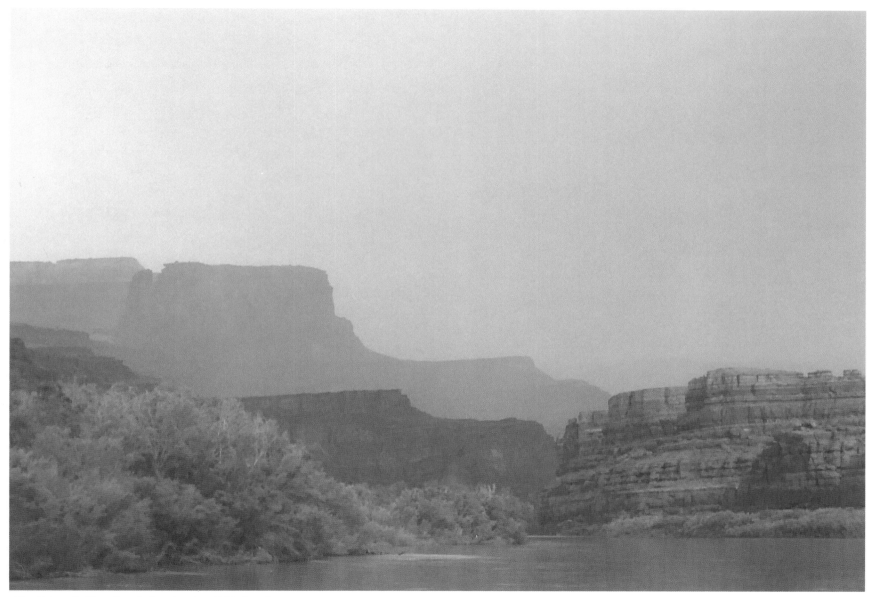

The Colorado River, headed upriver in a lightning storm

without even knowing it. The sun came back out, as the boat pulled up to the Potash boat landing. We all trooped off, leaving gear on the jet boat. Kenny went to get the semi to load the jetboat, while Lorenzo held it steady in the river. Watching the two of them load that giant boat onto a flatbed semi was quite a sight.

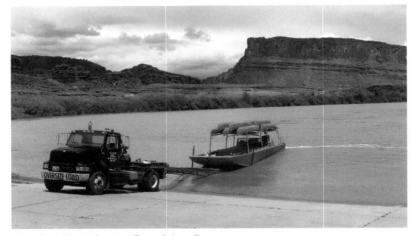

Loading the jet boat at Potash Landing

After ten minutes or so, we were all on board the yellow school bus for the trip back to Moab. The Colorado River runs right beside the road on one side, and the railroad serving the potash plant runs on the other. There are several BLM campsites, and trails lead off to Corona Arch and Bowtie Arch. We got back to Tex's just in time for more rain. Waiting it out inside the office, it took a few minutes for Kenny to get back with the boat and everyone's gear.

Outside in the parking lot, we all chipped in to get the gear on the ground. Jim spent a few minutes on the phone with his wife Lynne, to cancel our hotel reservation for two days in the future, and book a room for the next two days. We loaded our stuff into the two pickups, and headed for a hot shower and some tasty Mexican food.

Home at last! Not exxactly dry land. (Raining in Moab when we got back.)

We spent the rest of the afternoon unloading gear from our trucks, and carting it into the Quality Inn. We had a much smaller room than our pre-trip suite, but it worked out. We got the gear sorted into two piles, drying what was still wet from the trip upriver. I cleaned my camera and lenses as much as possible, getting the minute dust and grit out of the surface cracks. Jim and I washed some river mud off in the shower, and hung stuff on every available surface to dry.

We had another terrific dinner at Fiesta Mexicana, where gorging on cheese, beans and tortillas seemed like the right thing to do. The rain kept up, off and on, most of the evening.

DAY NINE — THURSDAY, MAY 23

MOAB

Another trip was made to the Moab Garage next day, along with a walk down to Tom Till's art gallery. Till is a well-known photographer, a Moab native, who runs workshops and sells large metal and canvas prints. We chatted with the woman tending the store, and dodged raindrops on Main Street heading to another gallery to look for gifts for Lynn. We stopped in at Gearheads again, to see if we had left any stock on the shelves. Dinner the last night at Thai Bella (my third time). The weather on Wednesday afternoon and most of the day on Thursday was cold and rainy. We were thankful to have gotten off the river early. It would have been miserable canoeing in the wet, with the danger of lightning, and nowhere to land.

DAY TEN — FRIDAY, MAY 24

MOAB TO DENVER

Friday morning, we slept in, more or less. Had our usual breakfast, and I loaded up my truck for the drive up to Denver. The rain had stopped, more or less, and the day promised sunny blue skies. I planned to see my niece Sarah, her husband Brandon, and their new baby, Maren in Denver that night, but I had a few spare hours. Getting on the road around ten, I had the brilliant idea to head over towards Dead Horse Point. Just to see it, and

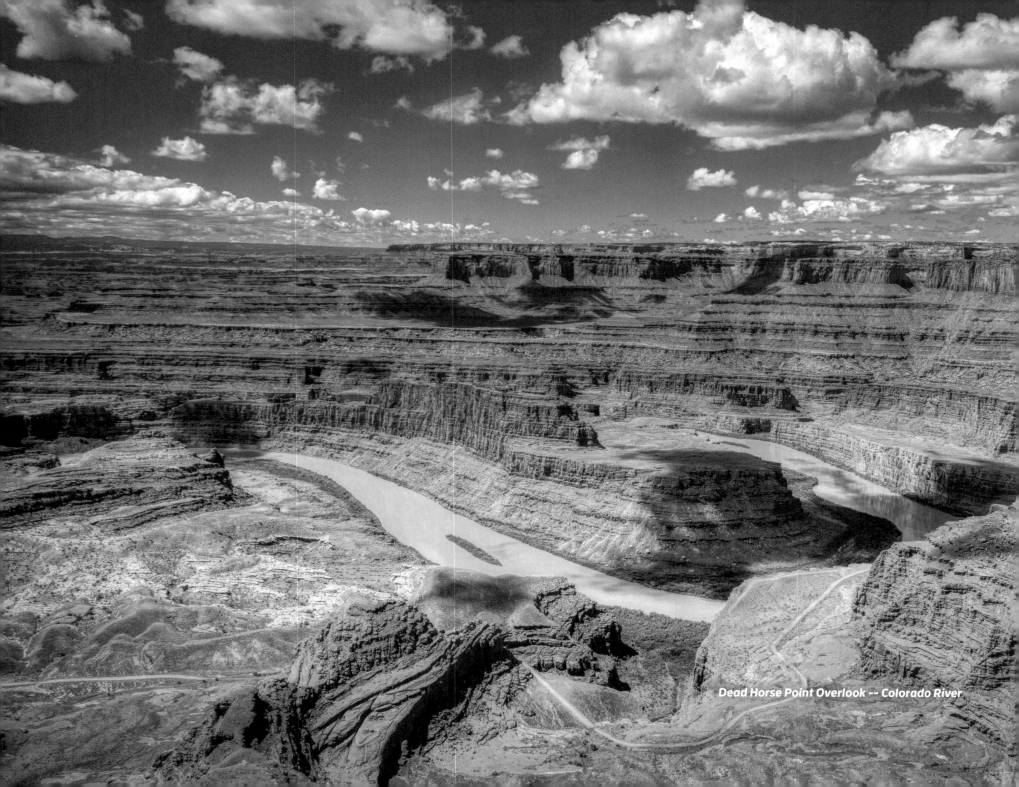

Dead Horse Point Overlook -- Colorado River

stand on the edge. Along the way, I realized that this was the route we took to get to Mineral Basin. Neither of us had gotten any good shots of the road down to the Green River put-in, so I changed my plan, and drove down what I thought was Mineral Basin Road to get that last shot.

Since the last three days had been somewhat wet, the road had a few muddy spots, and some standing water. Carefully negotiating the worst of them, the road was passable. But somewhere along the route, I made a wrong turn and drove 10 miles down the wrong road. I never did get to the Mineral Basin Overlook. Once realizing my mistake, I reversed direction, and drove over to Dead Horse Point.

At Dead Horse, it's easy to see the attraction. The Colorado snakes its way around several buttes, and the road to the point offers some spectacular views of the canyon. I saw several groups of bikers riding far below on Shafer Canyon Road, and a couple of rafts negotiating the oxbow. I hiked around a little bit to get a feel for the views, and then hit the road for Denver.

HOME --SUNDAY, MAY 26

LAST WORDS

This was an epic trip, in many ways. I'm not a water person, and so the second half of the journey challenged me. I learned a few things along the way.

First off, to have faith and trust in my higher power. Our paddle could have ended very badly at Anderson Bottom, and it did not.

Secondly, we learned some things about teamwork. For me, it was tough to juggle map reading and steering the boat from the stern—if the bow person reads the map, that's a good division of labor. Both paddlers absolutely have to trust each other, and communicate intentions.

Food-wise, I always carry extra portions. We never went hungry. In fact, we ate really well. Even though the food box got dunked.

My system for treating water on the river worked well—alum, let the water settle overnight, filter. It required a pre-prepared solution of alum, a collapsible bucket, and a Pur water filter. The extra weight from three large water containers made the canoe very heavy in the water. I should have dumped at least one of them at Anderson Boittom.

In retrospect, it would have been good to have another canoe party for safety and emergencies. Even hiring a guide who knows the river would have added some peace of mind, helping to find landings, and camping spots. Taking these lessons to heart, it will still be a long time before I set foot in a canoe!

A WORD ABOUT MENUS

TRIP FOOD PLANNING

It took a lot of preparation to get ready for this trip. Once I knew we were going, I started dehydrating ingredients. Dried vegetables, jerky, and tomato sauce have been a staple of my backpacking experience for years now.

I use an American Harvest dehydrator. Made by Nesco, it has variable temperature and several trays, so it can handle a number of things at once. Before I found out that Jim didn't eat meat, I started experimenting with dried chicken and hamburger, and made some of my favorite teriyaki beef jerky. Once I learned that he preferred not to eat meat, I changed course.

Because I didn't have the severe weight restrictions of a backpacking trip, I was able to include some canned items to add to our deluxe menus. A can of petite shrimp and pad thai sauce; chocolate syrup for trail angel cake; tortellini, pesto in a jar. Jim brought canned wine and some little bottles of after-dinner liqueur, which we enjoyed on our last night at Spanish Bottom.

For breakfast and lunch, we brought our own food. I prefer a hot breakfast of oatmeal or grits, some coffee; Jim liked his peanut butter and crackers. I brought some pita bread to make tuna sandwiches, but unfortunately it got drowned in our first dunking at Millard Creek. Tuna comes packaged in airtight pouches, so

the weight hit isn't too bad. We both munched on trail mix and hand food. One thing I learned is that it's impossible to make a sandwich while paddling a canoe. Hand food like trail mix works best while on the river.

There's a great resource for dehydrating and backpacking menus on the web: Chef Glenn has many, many tips on drying food, trail-tested recipes, and even desserts, like Trail Angel Cake (delicious!) Check him out: https://www.backpackingchef.com/backpacking-recipes.html

Some of things I dehydrated:

Chicken

Ground Beef

Beans: Kidney, Cannellini, Black

Angel Food Cake

Mashed Potatoes

Tomato Sauce

All of this was pre-packaged per meal, per day, and vacuum sealed with a Food Saver machine. This saved our bacon, literally, when the canoe capsized. Even though the food was not in dry bags in the food box, most of it survived. After the second capsize, I used a spare dry bag to protect the remaining meals against another dunking. Thankfully, that never happened. We

did lose some non-vacuum sealed food. Most notably, the pasta pesto sprang a leak and got soaked. We ate it anyway.

The most popular meal we had was the chili mac. Other meals included:

Couscous with Mushrooms and Pine Nuts

Ratatouille

Rigatoni Marinara

Shrimp Pad Thai

Cheese Tortellini

Chili Mac

Shepherd's Pie

Apple Curry with Rice

Setting up the MSR Whisperlite at Fort Bottom, Day One Photo: Jim Beasley

For dessert, we had fruit cocktail (pre-packaged in snack packs), the afore-mentioned Trail Angel Cake, Lemon Pudding Cake, Apple Brown Betty, Chocolate Mango Pudding, and Nutter Butters. And we carried after dinner cocktails—my drink of choice was a pint of Tin Cup American Whiskey, carried in a pint Nalgene bottle.

In short, we ate well.

BIOGRAPHY

James Parker was born in South Dakota. Growing up as a boy in the Black Hills of South Dakota, he was introduced to the creative pursuits early on, by his father, Dr. Watson Parker. Dr. Parker taught James to read and write at ripe young age of 5 years old.

Both father and grandfather wrangled horses, tourists and children at Palmer Gulch Lodge, a guest ranch. His father gave him his first camera when he was 7. Watson showed him how to use the Brownie, gave him a roll of film, and told him to bring it back when he was done exposing the negative. James went through a number of hand-me-down cameras — an old Voigtlander, an Argus C3, a Mamiya and others, before finally getting a decent SLR after college.

James's degree is in Visual Communication. After graduating from the University of Wisconsin, he went to work for a friend of Watson's who taught him the ropes in advertising. Hugh Lambert also taught James how to visualize and how to think about light. Much of the scientific method he takes for granted now was learned at Hugh's knee. Parker worked for several ad agencies over the next thirty years, moving up from junior art director, to Creative Director, to Managing Director at the Chicago office of a national interactive marketing services firm. In between, James met his wife, got

Parker, Devil's Playground, Arches National Park
Photograph: Jim Beasley

married, and partnered up with some old friends in Chicago, all the while still shooting Out West.

After leaving the Windy City, Parker moved back to Michigan, and began pursuing his dream of shooting full-time. He purchased his first digital SLR, his first pigment printer, and then his second printer. And my third. He did his first show, in Muskegon in 2005, and won his first award check. That was sweet. James went through a couple of trailers, and put a lot of miles on his Jeep before graduating to a full-size truck.

With his background in advertising and art direction, Parker has branched out into helping others tell their own stories. From consulting and free advice, to designing books and shooting assignment photography, Parker is uniquely positioned to offer his 40 years of experience to corporate and private entities. Learn more about his photographic work, as well as some of his recent project work at http://www. parkerparker.net

Parker and his wife Karyn make their home and studio in Rochester Hills, Michigan.

CPSIA information can be obtained at www.ICGtesting.com
Printed in the USA
BVIW121024130720
583612BV00008B/17

9 781734 910018